IMAGES
of America

MONTEREY'S
WATERFRONT

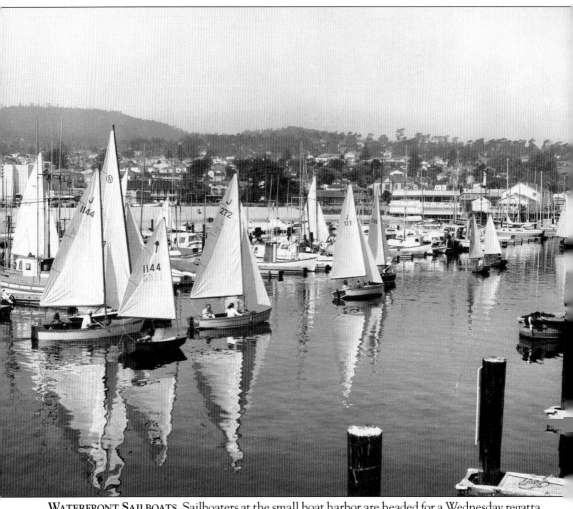

Waterfront Sailboats. Sailboaters at the small boat harbor are headed for a Wednesday regatta on Monterey Bay in September 1960. (William L. Morgan photograph; courtesy Monterey Public Library, California History Room.)

On the Cover: In 1908, Monterey fisherman Luis Perez (far left) was known locally as the "Fish King." Perez was fishing one day for rockfish when he accidentally caught a basking shark. He brought this strange animal to the Monterey Wharf where his friend Manual Duarte, who ran a small fishing store catering to tourists, thought they could make some money. The partners soon put up a small tent on the beach next to the Monterey Wharf, placed the shark inside, and charged 50¢—a good sum in 1908—just to look at a dead shark. According the Monterey newspaper at the time, that shark was exhibited for 10 days. (A. C. Heidrick photograph; courtesy Monterey History and Art Association.)

IMAGES
of America

MONTEREY'S WATERFRONT

Tim Thomas of the
Monterey Maritime and History Museum
and Dennis Copeland

ARCADIA

Published by Arcadia Publishing
Charleston SC, Chicago IL, Portsmouth NH, San Francisco CA

Printed in the United States of America

Library of Congress Catalog Card Number: 2005929107

For all general information contact Arcadia Publishing at:
Telephone 843-853-2070
Fax 843-853-0044
E-mail sales@arcadiapublishing.com
For customer service and orders:
Toll-Free 1-888-313-2665

Visit us on the Internet at www.arcadiapublishing.com

*To William "Rip" Ripley and Tom Fordham, who would have
loved this book.*

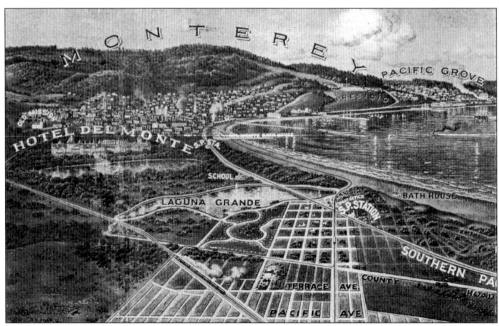

BIRD'S-EYE VIEW. This is a pictorial map showing Monterey's waterfront on Monterey Bay along
with Del Monte Heights (later becoming a part of Seaside), a subdivision of the Hotel del Monte,
around 1907.

CONTENTS

ACKNOWLEDGMENTS

We wish to first thank our respective institutions, the Monterey History and Art Association and the Monterey Public Library, for their support and for the care and custody of the historical collections from which the photographs have been drawn. The association's Monterey Maritime and History Museum and the library's California History Room Archives contributed many stunning images, each with a story to tell.

We especially want to offer our heartfelt thanks to digital scanning wizard John Castagna for his talent and unswerving patience. GMR Custom Photograph also provided expert photographic scanning. Hannah Clayborn, our editor at Arcadia Publishing, gave guidance and unswerving support during some difficult times. Over the years, many donors have contributed the photographs and materials used in this book. We would like to specifically express our appreciation to William Takigawa, Frances Yee, the late Tom Fordham, and the other donors as noted with their photographs.

Perhaps most vital to our project were the exceptional photographers, including Lee Blaisdell, Julian P. Graham, A. C. Heidrick, Phillip Lewis, William L. Morgan, Joseph K. Oliver, and Julius B. Phillips, and many others who captured visually the history and life of Monterey's waterfront. We would also like to thank Barbara Briggs-Anderson for the generous use of the photographs by Julian P. Graham, including two from the Julian P. Graham Historical Photographic Collection, Loonhill Studios. And, of course, we could never have completed this book without the fishermen, scientists, canners, and others whose stories and work contributed so much to Monterey's fishing and waterfront history.

Finally, Tim would like to give special thanks to Linda Yamane, who always made me tell the truth! To all the boys at the Tom Fordham Coffee Club who kept me on my toes, to Pat Sands for opening her father's incredible archives and allowing me to use it, and especially to Dennis Copeland for his friendship, patience, and collaboration. Without him, this book would not be possible.

INTRODUCTION

For centuries, Monterey's waterfront has been the gateway to Monterey Bay's beauty and resources. Seeing the bay for the first time in 1847, Lt. William Tecumseh Sherman described it as "shaped somewhat like a fishhook, the barb being the harbor, the point being Point Pinos, the southern headland." What a perfect description of Monterey Bay.

For thousands of years prior to the arrival of the first Europeans in 1602, native peoples made their living fishing Monterey Bay. The Rumsien Ohlone, the native people of the Monterey area, were the first real "commercial" fishermen. Nearly every species of fish that swam in the bay was caught, used, and traded, and of course sea otters, sea lions, and seals were used not only for food but also for their pelts to make blankets and capes.

The bay has changed since that time. Several different ethnic groups have brought their own maritime expertise and fishing methods to the waterfront. Boats became bigger, and newer technology made things faster and easier.

From a large Rumsien Indian fishing village situated along the shore to a small Spanish presidio built in the late 18th century, the physical appearance of Monterey's waterfront also began to change. In 1827, the Custom House was built on a small cliff overlooking the harbor. It is now the oldest government building in California. Two wharves were built. The first was constructed in 1845 to accommodate passengers and cargoes arriving by sea and operated as the first working wharf for fishermen. The second, still known as the "New Wharf," was completed in 1928 to accommodate Monterey's growing sardine industry. A breakwater was put in from 1932 to 1934 to help protect Monterey's fishing fleet from storms. Several piers were built and later dismantled, including the Southern Pacific and Associated Oil piers. There were whaling stations, a rail station, a luxury hotel bathing pavilion, and even an oil-tank farm. There were fishermen, boatbuilders, and canneries, and each one brought a unique style and character to the Monterey region.

During the Spanish and Mexican periods, Monterey was the capital and port of entry to Alta (Upper) California. Although the Spanish colonists and their descendants, the Californios, were not fishermen by trade, they certainly relied on the bay to help them survive. In 1822, when Mexico declared its independence from Spain, the new government opened the Puerto de Monterey to foreign trade. Whaling ships from England, France, and the United States sometimes hunted whales in the bay and their crews would fill the streets and saloons with exotic sounding languages and customs. Trading ships from Boston and New York would bring much sought-after goods to exchange for cowhides and tallow.

When war broke out between the United States and Mexico, American marines and sailors raised the American flag over the Custom House on July 7, 1846, ending the Mexican rule of California. When gold was discovered on the American River in 1848, many Montereyans left the old waterfront town for the gold fields. Then, with the influx of returning miners and new settlers, the old capital and port of California became the site of the first convention to debate and establish a California constitution in 1849.

In the 1850s, a small group of Chinese fishermen and their families settled along the Monterey waterfront near the present-day Monterey Bay Aquarium. They built one of the largest thriving Chinese fishing villages on the West Coast, harvesting abalone, squid, and fish. According to one newspaper account, the enterprising fishermen caught everything "from shark to shiner." Around the same time, Capt. John Davenport, a semiretired whaler out of New Bedford, Massachusetts, and Capt. Joseph Clark, a Portuguese whaler, arrived to start a small whaling company on the shores of Monterey Bay.

Finally in 1874, the narrow-gauge Monterey & Salinas Valley Railroad (MSVRR) pulled into town and changed the history of Monterey forever by providing a way to get fresh fish to the larger markets. In 1880, the Southern Pacific Railroad bought out the narrow-gauge MSVRR and began running trains from San Francisco to Monterey. SP's real estate arm, the Pacific

Improvement Company (precursor of today's Pebble Beach Company) quickly purchased several thousand acres of the Monterey Peninsula, including most of the Monterey waterfront. It was the dream of Charles Crocker, the banking and railroad baron, to turn Monterey into a tourist paradise. Of course "paradise" needs a place for people to stay and the Hotel del Monte, "queen of American watering holes," was born. One of the many recreational activities offered by the new luxury resort was sports and deep-sea fishing.

By the 1890s, a new immigrant group arrived, the Japanese. They quickly recognized the amazing abundance of fish and red abalone in Monterey Bay and over the next 20 years, dominated both the salmon and abalone industries. With the help of German restaurateur "Pop" Ernest Doelter, the Japanese popularized the abalone into a marine delicacy.

Around the turn of the century, the discovery of abundant salmon in Monterey Bay led to the establishment of the first processing plants. Frank E. Booth built his cannery next to Fisherman's Wharf and eventually turned to canning the pilchard, a large sardine. Sicilian fishermen, who had already worked for Booth on the Sacramento River, came to Monterey to fish for sardines. That small beginning was the genesis of the great sardine industry at Monterey. For almost 50 years, the Sicilians and sardines ruled the bay, making Monterey the "Sardine Capital of the World." Yet the smelly sardine industry at one time competed with the lavish Hotel del Monte for the waterfront. Knowing that the sardine industry was profitable, Monterey's civic leaders proposed that canneries could be built along Ocean View, west of Old Town Monterey. And so, the famed Cannery Row was born.

Explorers and scientists have been combing Monterey's waterfront ever since the French explorer, Jean Francois de La Perouse, dropped anchor in Monterey harbor in 1786. Scientists have delighted in this marine biological utopia from that day on. In the 20th century, California's Department of Fish and Game scientists began collecting and studying the diversity of marine life off Monterey's shores. They also monitored the growing sardine industry and forewarned of its decline. Among the scientists of Cannery Row was Ed Ricketts, who became famous (despite his own scientific research) as the fictional character "Doc" created by his friend John Steinbeck in the novel *Cannery Row*.

For generations, people have been coming to Monterey to make their living from Monterey Bay's rich bounty, each bringing their own ideas and customs. For these diverse cultural groups—from Southern Europe to the South China Sea—the one constant was that they all said how much the Monterey Bay looked like home. Throughout Monterey's history, both residents and tourists have enjoyed the beauty and richness of Monterey's scenic and vibrant waterfront. The following chapters tell its story and the story of the people who have made the waterfront their source of livelihood and perennial delight.

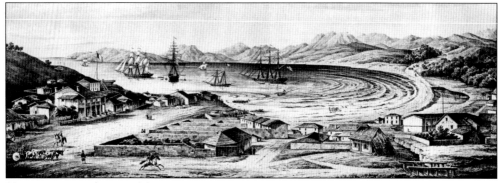

HARBOUR AND CITY OF MONTEREY, CALIFORNIA, 1842. Monterey's first and only American Consul, Thomas Larkin, commissioned this pictorial map depicting early Monterey. Larkin had the drawing done to show off his new home, seen in the middle at left. Note that prior to Larkin's wharf of 1845, both passengers and cargo were rowed by boat to shore near the Custom House. (Courtesy Monterey Public Library, California History Room Archives.)

One

EARLY MONTEREY

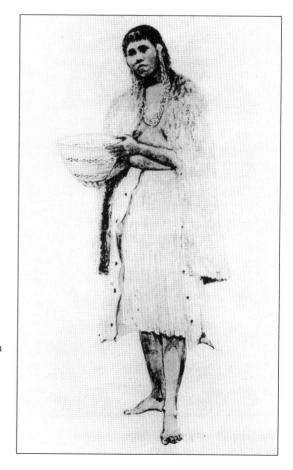

MONTEREY WOMAN. This drawing, by
Spanish artist Jose Cardero, depicts a
native Rumsien woman. The connection
the Rumsien people had to the sea can
be seen by noting her apparel, which
included a sea-otter wrap over a tule
skirt, an olivela and abalone shell
necklace, and ear pendants. (Courtesy
Monterey Public Library, California
History Room.)

RUMSIEN HUNTER. "We saw an Indian with a stag's head fastened on his own, walking on all fours and pretending to graze. He played this pantomime with such fidelity, that our hunters, when within thirty paces, would have fired at him if they had not been forewarned. In this manner they approach a heard of deer within a short distance, and kill them their arrows," wrote French explorer Jean Francois de Galaup de La Perouse, in Monterey, in 1786. (Linda Yamane drawing; courtesy artist.)

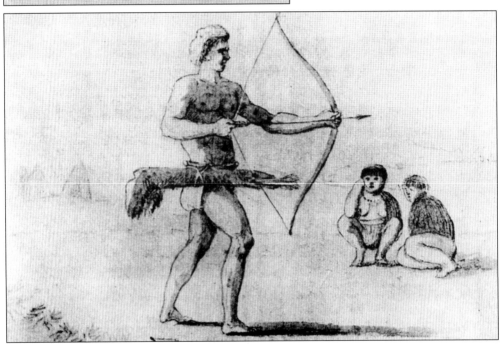

INDIO DE MONTEREY. Going back almost 5,000 years, the peaceful community of Rumsien fished the bay in small boats made of tule reeds, using a variety of fishing methods. These included nets made of string from the stinging nettle plant, traps made of willow, and harpoons made with bone points, as well as hook and lines using fish hooks made from abalone and mussel shell. (Jose Cardero drawing, 1791; courtesy Monterey Public Library, California History Room Archives.)

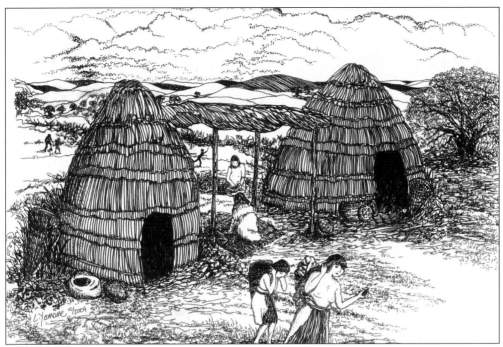

RUMSIEN VILLAGE. The Rumsien people were the first divers to harvest food from the bay as attested by evidence uncovered in ancient burial sites. Some of the males had what is known as "surfer's ear," a bony growth that closes off the ear opening and indicates that they spent a lot of time in Monterey Bay's cold waters. Nearly every species of fish that swam in the bay was caught and used. Sea otters, sea lions, and seals were used for food and for their pelts to make blankets and capes. (Linda Yamane drawing; courtesy artist.)

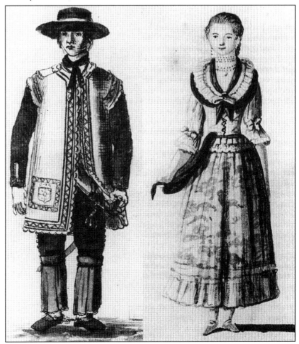

SPANISH SOLDIER AND HIS WIFE. Beginning in 1770, the Spanish sought to colonize Monterey, and it became the second European settlement of Alta California. The Spanish colonization effort utilized two principal institutions, the mission and the presidio or fort. Life in Monterey was hard for the earliest colonists, primarily soldiers, but the Rumsien people supplied them with food. Few of these soldiers were brought to farm, let alone fish the waters of Monterey Bay. It was not until Anza's expedition of 1776 that families and artisans began to settle Spanish Alta California. (Jose Cardero drawing.)

11

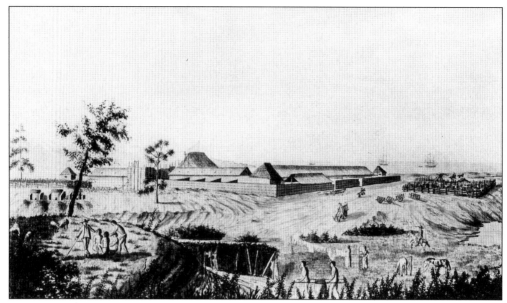

VISTA DE PRESIDIO DE MONTE REY. This is an early view of the Presidio of Monterey, around 1792, looking north towards the estuary (El Estero, at right) and Monterey Bay. Note the field crops and the supply ships in the harbor, which were probably Spanish. With few exceptions, Spanish policy closed the port of California at Monterey to foreign trade. (Jose Cardero drawing; courtesy Monterey Public Library, California History Room.)

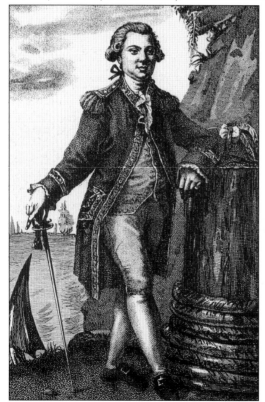

LA PEROUSE. Jean Francois de Galaup de La Perouse led the first scientific expedition to Monterey in 1786. While there, his party collected animal and plant samples as well as looked for good whaling grounds for the French whalers who were beginning to venture into the Pacific. (Portrait by an Italian engraver; published in the *California Historical Society Quarterly*, Vol. 20, 1941.)

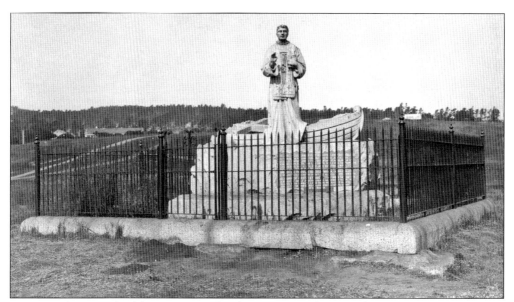

JUNIPERO SERRA. The life-size statue of Father Serra standing in a boat depicts his landing on Monterey shores from the ship *San Antonio*. Located on the (second, American) Presidio of Monterey, not far from the traditional landing site, the 1891 monument was a gift from Jane L. Stanford, the wife of railroad magnate and former governor and senator Leland Stanford. (C. K. Tuttle photograph; courtesy Monterey Public Library, California History Room.)

SERRA'S LANDING. It was here that the explorer Sebastian Viscaino landed in 1602, claiming the land for Spain and bestowing on it the name Monterey in honor of his patron, the Viceroy of New Spain, Count of Monterrey. However, it took 168 years before the Spanish returned to settle the region. On June 3, 1770, Junipero Serra landed on this spot and, with Capt. Gaspar Portola, founded Monterey. (C. W. J. Johnson photograph; courtesy Monterey Public Library, California History Room.)

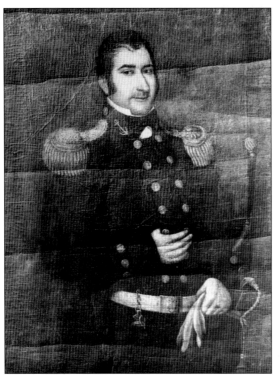

RAID BY SEA. In 1818, Hippolyte Bouchard, a French-born privateer and agent of the Argentine government, sailed into Monterey harbor aboard his flagship *La Agintina*. Bouchard planned to take the town and burn it to the ground as part of a revolution against Spain. Meeting little resistance, except for some early cannon exchange, Bouchard disembarked his troops and raised the Argentine flag over the presidio. Monterey's people had fled, leaving little for Bouchard's men. He did take on some water and pigs and learned that adobe does not burn well. He sailed away about a week later. (Photograph of portrait by Lee Blaisdell; courtesy Monterey Public Library, California History Room.)

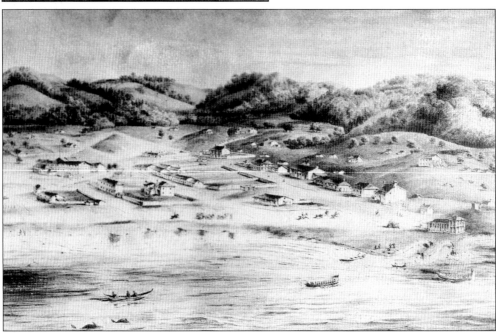

VIEW OF MONTEREY IN 1842, LOOKING TOWARD MONTEREY FROM THE BAY. Note the fishermen in the boat. This is probably the earliest contemporary scene of fishing in Monterey Bay. The 1836 census of Monterey lists three fishermen living together: Juan Bautista Griego, a 48-year-old Greek; Luis, 26 years old from Genoa; and Matias, a 30-year-old man from Venice. Are they the ones in the boat? (Courtesy Monterey Public Library, California History Room.)

OTTER. On October 29, 1796, the *Otter* dropped anchor in Monterey Bay, becoming the first American ship to visit California. It was fitted for the sea-otter trade. At the time, a good sea otter pelt could fetch as much as $300 in Canton, China. The *Otter* deposited 11 stowaways from the British penal colony at Botany Bay, Australia, who were left on the beach to fend for themselves. (Courtesy Monterey History and Art Association.)

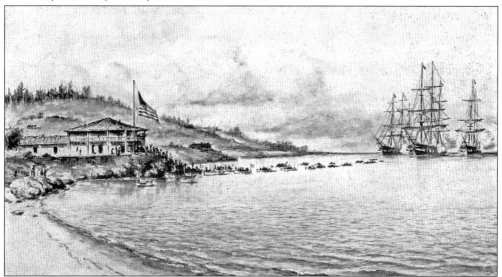

SLOAT'S LANDING. The raising of the American flag over the Custom House on July 7, 1846, by Commo. John Drake Sloat, commander of the American naval forces in the Pacific, established the United States' formal possession of California. Sloat's proclamation, read in English and Spanish, assured all California residents the same constitutional rights as all Americans. As the sailors and marines cheered, a 21-gun salute boomed from the cannons of the American ships, and Monterey passed without bloodshed into the hands of the United States. Later that day, over 100 marines, many of them with musical instruments, paraded down Calle Principal, then the main street, playing "Yankee Doodle Dandy." (William A. Coulter drawing; courtesy Monterey Public Library, California History Room.)

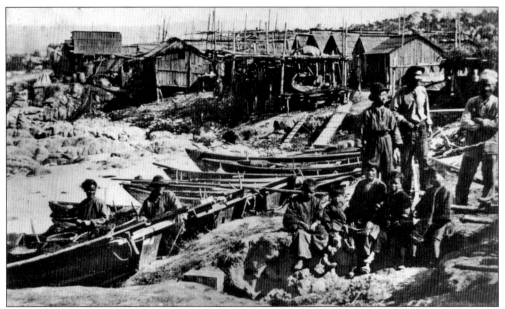

FISHING VILLAGE, 1875. This is perhaps the earliest image of the Chinese fishing village. It eventually covered the area from Cabrillo Point (or Point Alamejas or Mussel Point), where the Hopkins Marine Station is located, to Point Alones (Rumsien for abalone), where the Monterey Bay Aquarium is located. Note the children in the photograph. They were probably born in Monterey, making them American citizens. (Martin Dressler photograph; courtesy Monterey Public Library, California History Room.)

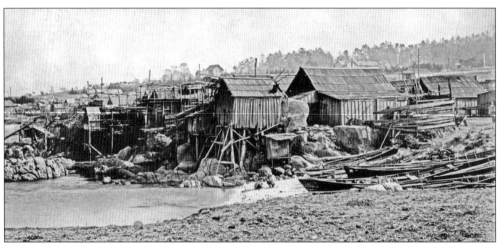

CHINESE FISHING BOATS. The Chinese fishing boats with the flat bottoms could easily be hauled out of the water. Chinese fishermen and their families first arrived here in the early 1850s, sailing across the north Pacific in small 30-foot junks. These mariners depended on currents that they called the "Black Tide," which pushed them toward Cape Mendocino in northern California. They then sailed down the California coast, landing initially at Point Lobos and then settling in villages on the Monterey coast. (J. K. Oliver photograph; courtesy Monterey Public Library, California History Room.)

Two

FROM SHARK TO SHINER
THE CHINESE FISHING COMMUNITY

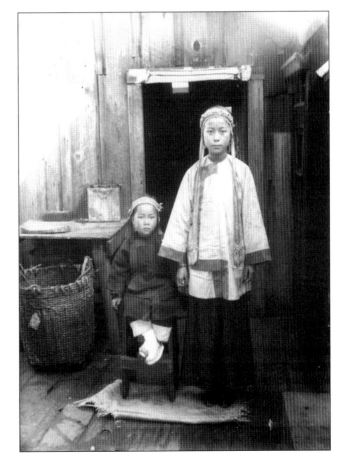

TWO SISTERS. By 1854, the Chinese settlers had built a village along the Monterey waterfront on Cabrillo Point or Point Alamejas. This became the largest of the Chinese fishing villages along the West Coast. Both men and women worked in the fishing industry. These two sisters are from the Cabrillo Point village. (J. K. Oliver photograph; courtesy Monterey Public Library, California History Room.)

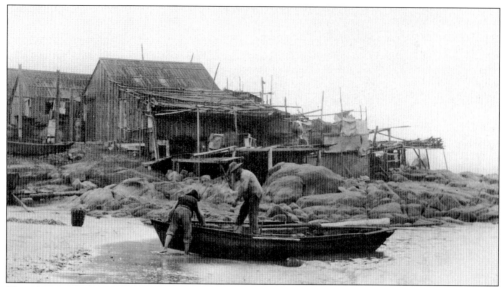

Two Chinese Fishermen. Chinese fishermen ready their boat for fishing off the village shore. (J. K. Oliver photograph; courtesy Monterey Public Library, California History Room.)

Village and Boats. In this view of the village from the bay, note the wire basket in the stern of the closest boat. The Chinese had learned years before that squid are nocturnal. If they burned pitch fires off the back of their boats, it attracted them to the surface. Not wanting to compete with the newly arriving Italian fishermen, the Chinese began fishing at night for squid. (C. K. Tuttle photograph; courtesy Monterey Public Library, California History Room.)

READYING A SQUID BOAT. Fishermen push a boat out from the village shore for a night of fishing squid. (J. K. Oliver photograph; courtesy Monterey Public Library, California History Room.)

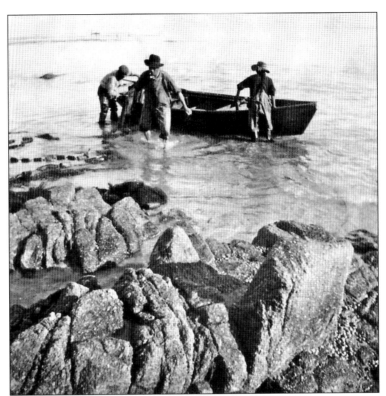

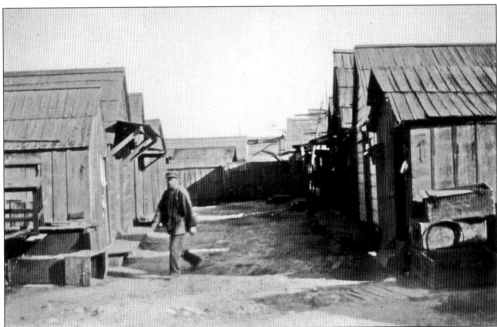

DOWNTOWN CHINATOWN, 1901. The Chinese fishing village, set on a sheltered cove, was the center of the Chinese fishing industry in the region. The first settlers in the mid-1850s came for abalone and later for squid and fish. The settlement was unique in California for having a large number of women and children. (Courtesy Monterey Public Library, California History Room.)

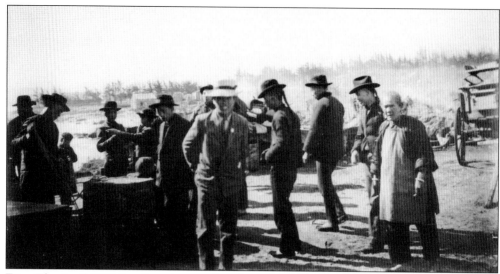

FIRE. The April 1906 San Francisco earthquake and fire displaced many San Francisco families, including Chinese. Having no place to go, some went to the Point Cabrillo village, and it thus grew. On May 16, 1906, almost a month to the day of the earthquake, a fire broke out in a barn, burning most of the village to the ground. Luckily no one died. This photograph was taken the day after the fire. (J. K. Oliver photograph; courtesy Monterey Public Library, California History Room.)

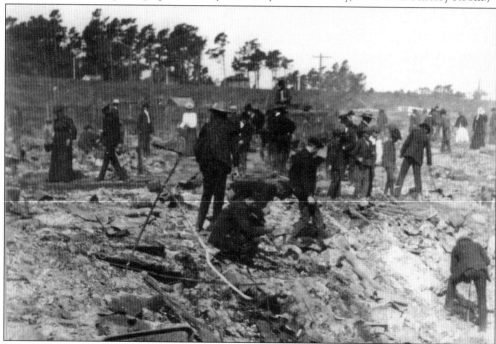

VISITORS VIEW THE LOSS. After the fire, the good citizens of Monterey and Pacific Grove visited the village to see what "souvenirs" they could find. It still took the Southern Pacific almost a year after the fire to move the Chinese community from the village site. When the Chinese left, may went to San Francisco. A smaller group moved to a small beach on Cannery Row called McAbee Beach. That village continued into the early 1920s. (J. K. Oliver photograph; courtesy Monterey Public Library, California History Room.)

20

Three

WHALING

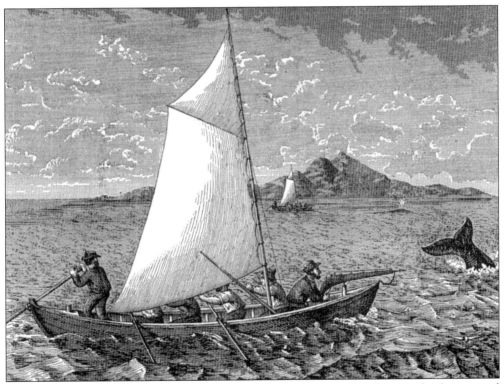

WHALE BOAT ON BAY, AROUND 1874. This is a typical Azorean whaleboat, with a lanteen sail rig and mounted "greeners gun" that can be seen on the bow of the boat. Scammon described these boats as having eyes painted on the bow and stars and moons on the sails. (Drawing by former whaler Charles Scammon.)

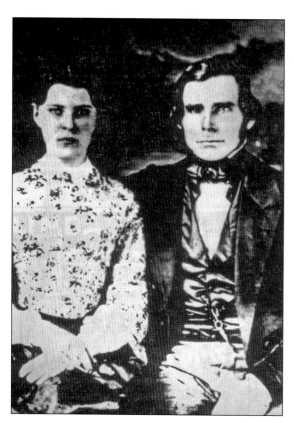

Capt. John Pope Davenport and Wife Ellen. In spring 1854, Captain Davenport, a semiretired whaler out of New Bedford, Massachusetts, and his partner, Capt. Joseph Clark, a Portuguese whaler, started a small whaling company on Monterey's shores. The first crew included Monterey men with no whaling experience. Meeting little success, this company disbanded after one season. (Courtesy Tom Fordham.)

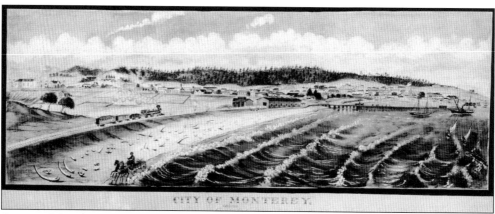

City of Monterey, November First, 1875. This painting by Leon Trousseau shows the beach next to the wharf and the recently established Monterey and Salinas Valley narrow-gauge train coming into Monterey. Note all the whalebones on the beach and the whaleboat out on the bay. (Photograph of painting by Lee Blaisdell; courtesy Monterey Public Library, California History Room.)

TOOLS OF THE TRADE. This Charles Scammon drawing, from around 1874, shows the gear that would be found on a typical whaleboat at the time. The techniques they utilized were what they called "the old fashioned way," or shore whaling. They would push off from the beach each morning in small 28-foot boats, using their sails. The whalers would quietly sneak up on the unsuspecting whales. (Courtesy Monterey History and Art Association.)

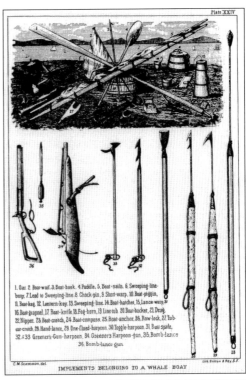

1. Oar. 2. Boat-waif. 3. Boat-hook. 4. Paddle. 5. Boat-sails. 6. Sweeping-line-buoy. 7. Lead to Sweeping-line. 8. Chock-pin. 9. Short-warp. 10. Boat-piggin. 11. Boat-keg. 12. Lantern-key. 13. Sweeping-line. 14. Boat-hatches. 15. Lance-warp. 16. Boat-grapnel. 17. Boat-knife. 18. Fog-horn. 19. Line-tub. 20. Boat-bucket. 21. Drag. 22. Nipper. 23. Boat-crotch. 24. Boat-compass. 25. Boat-anchor. 26. Row-lock. 27. Tub-oar-crotch. 28. Hand-lance. 29. One-flued-harpoon. 30. Toggle-harpoon. 31. Boat-spade. 32. & 33. Greener's-Gun-harpoon. 34. Greener's Harpoon-gun. 35. Bomb-lance 36. Bomb-lance gun

C. M. Scammon. del. Lith. Britton & Rey, S.F.

IMPLEMENTS BELONGING TO A WHALE BOAT

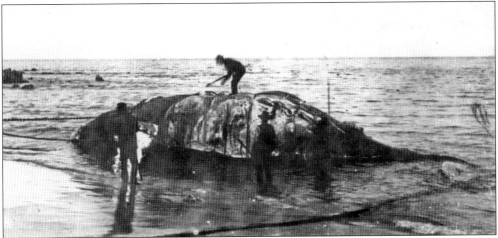

FLENSING OR CUTTING UP THE WHALE. The harpooner was also responsible for cutting the whale. After one was spotted, the harpooner threw the first lance into the whale. This first harpoon was attached to a rope connected to the boat. It was not meant to kill but rather slow the mammal down. If the whale did not turn and sink the boat, it usually took off dragging the men in the boat behind it for hours at a time. This was known as a "Nantucket sleigh ride." The citizens of Monterey lined up along the shore to watch these boats being dragged through the bay. Finally the whale would slow down and the harpooner would use his hand harpoons. Once the whale had been killed it would usually sink, so a marker would be put in place were it went down. The whale usually floated to the surface about 10 days later. The whalers would then tow the mammal back to shore, where the blubber would be stripped off for processing in try pots. (J. K. Oliver photograph; courtesy Monterey Public Library, California History Room.)

THE WHALING STATION. In 1855, a group of 17 whalers from the Azores, who had jumped ship in San Francisco to try their hands in the gold fields, heard of Captain Davenport's whaling venture. Not having any luck in the gold fields, they arrived in Monterey and formed their own whaling company. In their first season, from April through September 1855, they caught almost 20 whales, including 5 grays, 9 humpbacks, and 4 killer whales. Each crew member made $438 for his efforts. Although the shore whaling industry slowed down in the mid-1870s due to the invention of kerosene, it continued in Monterey until at least the turn of the century.

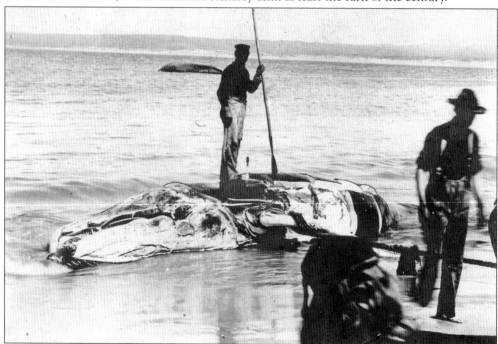

WHALING. By 1870, there were about five whaling companies working the Bay. Oftentimes more than one whaling company would converge onto the same whale and they would end up suing each other over which company owned the mammal. A California gray whale produces about 40 thirty-six-gallon barrels of whale oil. In 1870, a gallon of whale oil sold for about $1.50 a gallon, which was a lot of money. A judge would have to determine whose harpoon went into the whale first. (J. K. Oliver photograph; courtesy Monterey Public Library, California History Room.)

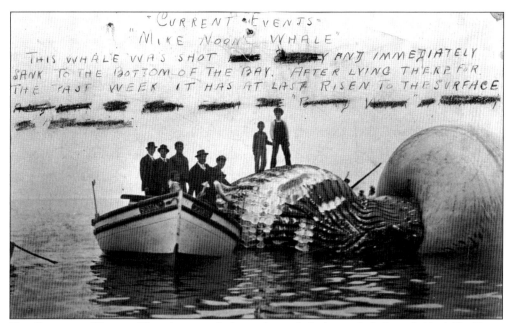

THE STINKING WHALE. This photograph shows the end of a later whale hunt led by Mike Noon in August 1911. After 1874, the whaling industry in Monterey began to slow down, not because too many whales were taken—they never took that many—but because other products were invented to replace whale oil, in particular kerosene. The whalers became farmers, dairymen, and other kinds of fishermen. (Courtesy Monterey Public Library, California History Room.)

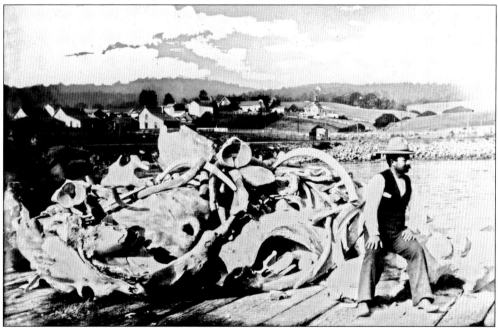

MIKE NOON. In this photograph, Monterey whaler Mike Noon sits on some whalebones on the Monterey Wharf. Marrying an Azorean, Noon became a member of the Azorean whaling community. He became wharf manager and was later elected city marshal. (J. K. Oliver photograph; courtesy Monterey Public Library, California History Room.)

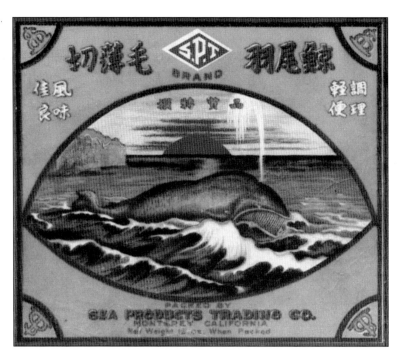

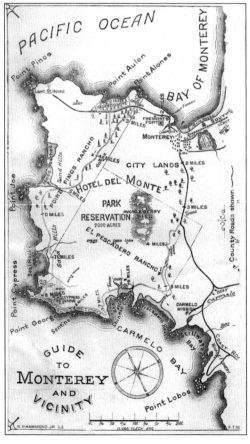

JAPANESE WHALE MEAT LABEL. This one-of-a-kind label is from the California Sea Products Company that operated on Monterey Bay from 1918 to 1926. It is thought that Hovden's sardine cannery on Cannery Row (where the Monterey Bay Aquarium is today) actually canned the meat. (Courtesy of Pat Sands.)

ODORIFEROUS BEAUTY. This is a map of the original scenic 17-mile drive from the Hotel del Monte around 1898. Note that the first stop was the Custom House and the whale fishery, where a person had the distinct pleasure of smelling dead whale. He or she would then continue to the Chinese fishing village where the smell dried squid could be taken in. (Courtesy of Monterey Public Library, California History Room.)

Four

HOTEL DEL MONTE AND EARLY SPORTFISHING

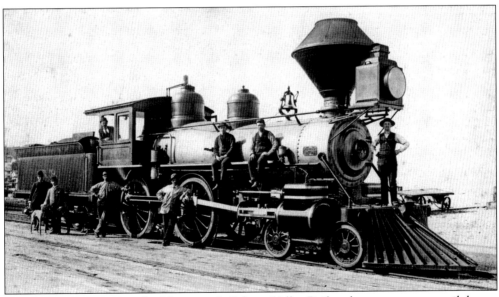

THE RAILROAD. In 1874, the Monterey & Salinas Valley Railroad, a narrow-gauge rail, began operation, changing Monterey forever. The MSVRR offered local farmers, fishermen, and merchants a way to deliver fresh fish, produce, and other goods to big markets in San Francisco and other cities. In 1880, the Southern Pacific Railroad bought the bankrupted MSVRR. Above is the Monterey Express locomotive No. 377 and crew in 1887. (C. W. J. Johnson photograph; courtesy Monterey Public Library, California History Room.)

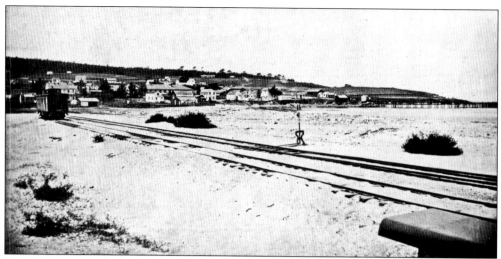

MONTEREY RAIL YARD ON THE BEACH, 1885. The early Monterey railroad traversed the Monterey beach; its station built in the sand. In this photograph, note the sand blown across the tracks, which was a constant problem to shippers and travelers. (Courtesy Monterey Public Library, California History Room.)

SHIPPING FISH. This shipping ledger is an example of records of fish and other products being transported to San Francisco and points beyond by the Monterey & Salinas Valley Railroad in 1875. The rail transport of fish sparked the fishing economy in Monterey. (Courtesy Monterey Public Library, California History Room.)

28

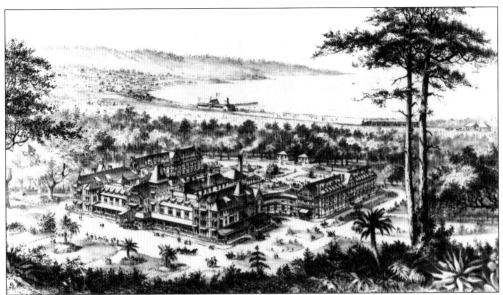

QUEEN OF AMERICAN WATERING PLACES. This early illustration advertised the advantages and luxury of the Hotel del Monte at Monterey. The Southern Pacific Railroad, which established the hotel, began running trains from San Francisco to Monterey in January 1880. It was the dream of Charles Crocker, the banking and railroad baron, to turn Monterey into a tourist paradise. Crocker's paradise needed a place for people to stay, so he built the resort hotel. (Courtesy Monterey Public Library, California History Room.)

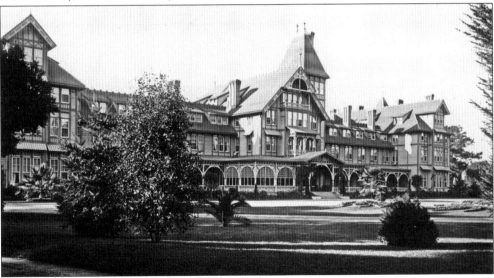

HOTEL DEL MONTE, 1887. Built in 100 days at a cost of $1 million on 125 acres of beautiful park-like grounds, the Hotel del Monte opened its doors on June 3, 1880. It was advertised as "the most elegant establishment in the world." Guests could stroll on miles of walking paths, enjoy beautiful gardens, and swim in the heated saltwater indoor bathhouse. They could also play golf, tennis, or polo. There was horseback riding and deep-sea fishing on the Monterey Bay. With daily rates of $4 to $6, the hotel quickly became the favorite of the rich and famous; its guests even included three presidents. (C. W. J. Johnson photograph; courtesy Monterey Public Library, California History Room.)

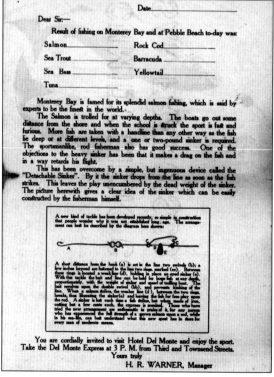

SPORTFISHERMAN. Above is Hotel del Monte's mailer that was sent to "sportfishermen" who had stayed at the hotel. Before the opening of the hotel in 1880, most of Monterey's fishermen fished with a gillnet, a net stretched between two boats. The fish swim into the net and are caught by the gills. This was fine for most fish, but not for salmon. In order to makes ends meet, Monterey fishermen hired themselves out as fishing guides to visiting sportfishermen. They fished for salmon with handheld trolling lines strung with hooks, which was a very effective way to catch salmon. Below is the flip side of the mailer, offering the latest in fishing technology, such as this salmon rig, which revolutionized Monterey's fishing industry. (Courtesy Monterey Maritime and History Museum.)

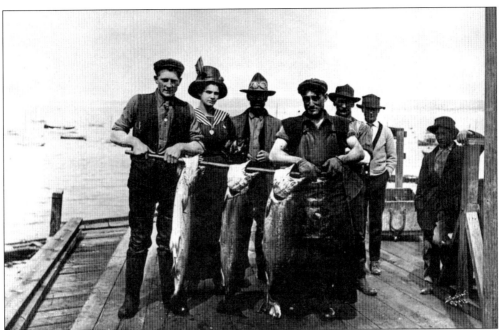

MONTEREY SPORTFISHERMAN, 1900. A group of Monterey's sportfishermen hold salmon caught in Monterey Bay. Within a few years, after fishermen switched their methods to trolling lines, large numbers of salmon were landed in Monterey. Because of these large salmon landings, a man named Frank E. Booth arrived in Monterey to open a salmon cannery. Booth also noticed the large numbers of sardines running in the bay in the fall and winter. He thought, "I can do something with that." (Courtesy Monterey Public Library, California History Room.)

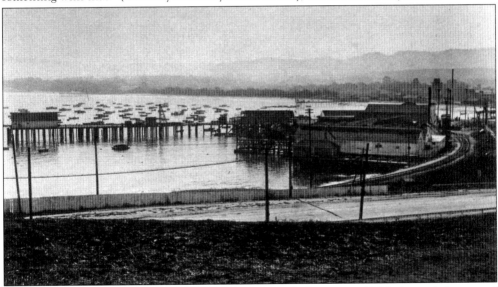

EARLY VIEW OF THE MONTEREY WHARF AND BOOTH'S CANNERY, 1909. Around the turn of the last century, the salmon fisheries along the Sacramento River weren't doing very well. Due to fishing-gear changes instigated by sportfishermen from the Hotel del Monte, and coupled with the arrival of some pioneering Japanese fishermen to the Monterey Bay, large salmon landings began to be made in Monterey. (Courtesy Monterey Public Library, California History Room.)

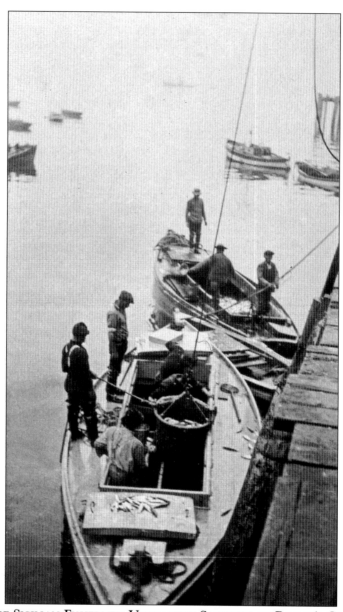

EARLY VIEW OF SICILIAN FISHERMEN UNLOADING SARDINES AT BOOTH'S CANNERY, 1909.
Salmon processors on the Sacramento River heard of the amazing catches in Monterey and sent
Frank E. Booth to investigate. Booth built a small shed near the Monterey Wharf for salmon
processing and experimenting with the plentiful large sardines, or pilchard, appearing in the bay
beginning in the late summer and early fall months. In 1900, H. R. Robbins leased a small piece
of property right in front of Booth's shed at the foot of Monterey Wharf. Robbins may have been
a wide-ranging businessman, for his lease stated that he operated a "sardine cannery, reduction
plant and dance hall." Booth bought him out in 1903 and took over his sardine cannery. Because
the large sardine was not immediately accepted, Booth promoted sales by variously advertising
them as "Soused Monterey Mackerel," or "Salmon" and "Herring" sardines. They were sardines
no matter what they were called. (Phillips Lewis photograph; courtesy Monterey History and
Art Association.)

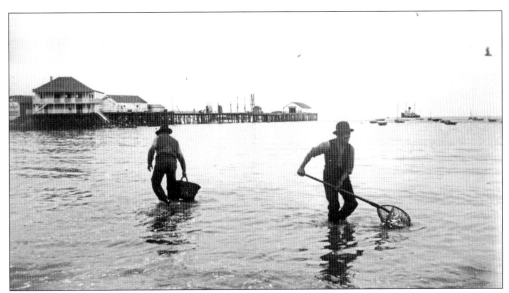

SMELT FISHING. These men are "fishing," or scooping up with nets, the smelt during the smelt run in Monterey Harbor around 1909. The two-story building (upper left) is the Boat Club, later to become Pop Ernest's restaurant, on the Monterey Wharf. (J. K. Oliver photograph; courtesy Monterey Public Library, California History Room.)

FERRANTE'S LANDING. This little wharf, in front of the Custom House and named for Pietro Ferrante, was built around 1906 to support the newly arriving Sicilian fishermen coming to work for Frank E. Booth. Ferrante was the pioneering Sicilian fisherman who worked for Booth and was responsible for bringing Sicilian fishermen to Monterey. He introduced the *lampara* (see page 49 for more) that revolutionized sardine-fishing technology. (Courtesy Monterey History and Art Association.)

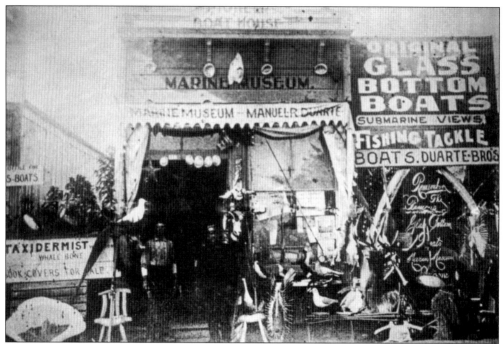

DUARTE'S EMPORIUM. This is the first maritime museum and aquarium in Monterey. Owned and run by the Duarte family in Monterey, Duarte's catered to the tourist industry, offering curios, boats, fish, and exhibits. Note the whalebone chair and vertebrae with the Carmel Mission painted on it. Manuel Duarte would have the Monterey whalers make these wonderful items to sell to the tourists staying at the Hotel del Monte. (Courtesy Monterey Public Library, California History Room.)

FOURTH OF JULY AT THE WHARF, 1898. This early view shows Duarte's first store and other buildings on the wharf. Fishermen's shacks are visible left of the entrance. The large flag is flying from the Custom House at right. (F. C. Swain photograph; courtesy Monterey Public Library, California History Room.)

Five

ABALONE, SALMON, AND THE EARLY FISHING INDUSTRY

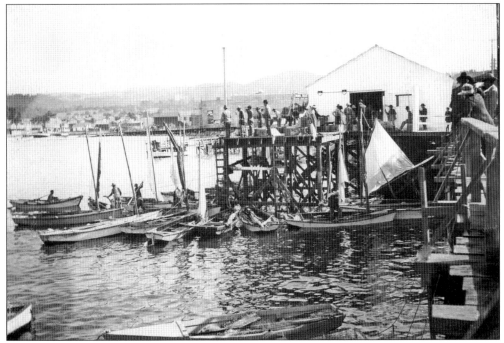

SALMON BOATS, 1907. Early Japanese salmon fishermen and boats line up at the Monterey Wharf. (Courtesy Monterey Public Library, California History Room.)

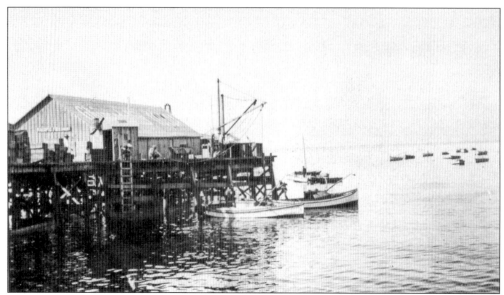

JAPANESE SALMON BOATS UNLOADING AT THE WHARF, 1909. After the United States imposed the Chinese Exclusion Act in 1882, Japanese immigrants to the West Coast increased. One of those immigrants was Otosaburo Noda, who settled in Watsonville in 1895. One day, while working in Monterey as a lumberjack for the Pacific Improvement Company (precursor of the Pebble Beach Company), Noda noticed the incredible variety of fish and red abalone in the Monterey Bay and that nobody was utilizing this resource. Leaving his lumberjacking, he moved to Monterey and started a small fishing colony consisting of several fishermen from Wakayama, Japan. (Phillips Lewis photograph; courtesy Monterey History and Art Association.)

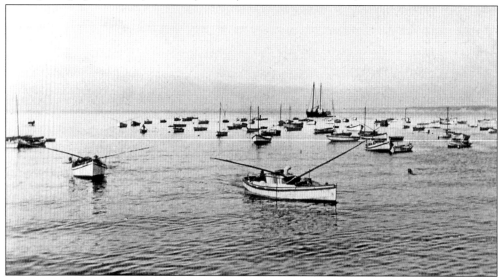

JAPANESE SALMON FISHING FLEET AT MONTEREY, C. 1909. The Japanese dominated the fishing industry in Monterey Bay, fishing for abalone and salmon, but salmon was king. In August 1909, at the end of salmon season, the *Monterey Daily Cypress* reported that there were 185 salmon boats fishing the bay; 145 of these boats were Japanese owned. In the short three-month season (May 15 to August 15), these Japanese fishermen brought in almost one million pounds of salmon. (Phillips Lewis photograph; courtesy Monterey History and Art Association.)

CRATED SALMON HAULED TO THE TRAIN STATION, 1909. Before 1915, most of the salmon caught in Monterey were shipped to Europe, 90 percent of which went to Germany. Most of the sardine supply in the United States came from Europe, primarily France. In 1914, the advent of World War I in Europe cut off the market for salmon shipments to Germany and sardines shipped from France. Fishermen began to heavily fish sardines along the West Coast. Eventually the sardine became the largest single fishery in the history of the United States. (Phillips Lewis photograph; courtesy Monterey History and Art Association.)

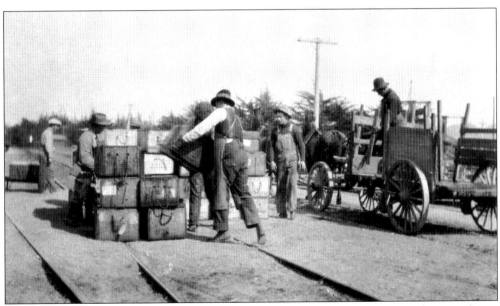

UNLOADING SALMON CRATES AT THE TRAIN DEPOT, C. 1909. These crates of salmon are being shipped to San Francisco where they will be prepared for shipment overseas. (Phillips Lewis photograph; courtesy Monterey History and Art Association.)

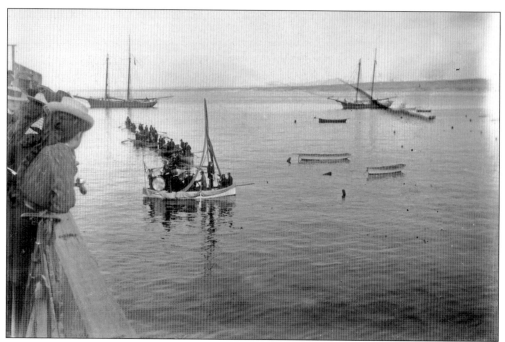

WATER CARNIVAL. The 1909 salmon season was a particularly good one, with over one million pounds caught. At the end of the season, the fishermen held a carnival for all of Monterey that included boat races and Japanese fireworks. Note the music band in the boat. (J. K. Oliver photograph; courtesy Monterey Public Library, California History Room.)

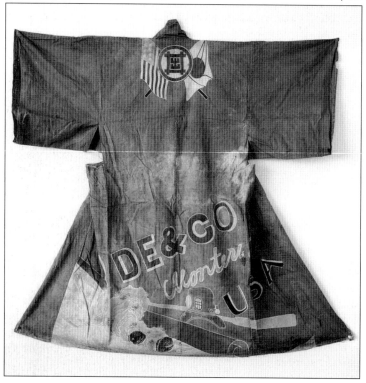

JAPANESE MAIWAI, AROUND 1900. This jacket is a celebratory coat given to Japanese fishermen at the end of a very good season. Written on the jacket is "Ide & Company, Monterey USA," a Monterey abalone company. It is one of only two known to exist: one in Japan and the other at the Monterey Maritime and History Museum. (Masahiko Aoki photograph; courtesy Yoshi Mitsuhashi.)

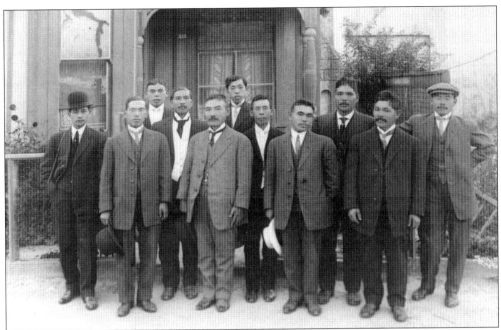

JAPANESE AMERICAN COMMUNITY LEADERS, C. 1914. Leaders of the Japanese business and fishing community stand in front of the Japanese American Citizen's League hall in Monterey. Pictured here, from left to right, are (first row) three unidentified men and fishery expert Otosaburo Noda; (second row) owner of Pacific Mutual Fist Company Unosuke Higashi (with hat), two unidentified men, marine biologist and abalone specialist Gennosuke Kodani, and unidentified; (third row) merchant Onojiro Uchida and fish wholesaler Setjsuji Kodama. (Kurt Loesch collection; courtesy Monterey Public Library, California History Room.)

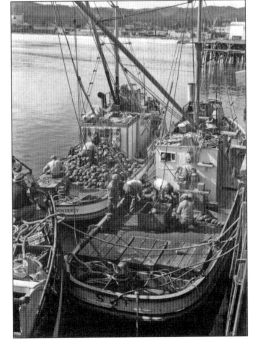

UNLOADING ABALONE. These are Japanese fishermen unloading an abalone boat at the Monterey Wharf in 1938. By 1920, there were 10 Japanese abalone companies working out of Monterey. Each boat would go out for three-day abalone cruises, coming back with over 150 dozen abalone per boat. (J. B. Phillips photograph; courtesy Monterey History and Art Association.)

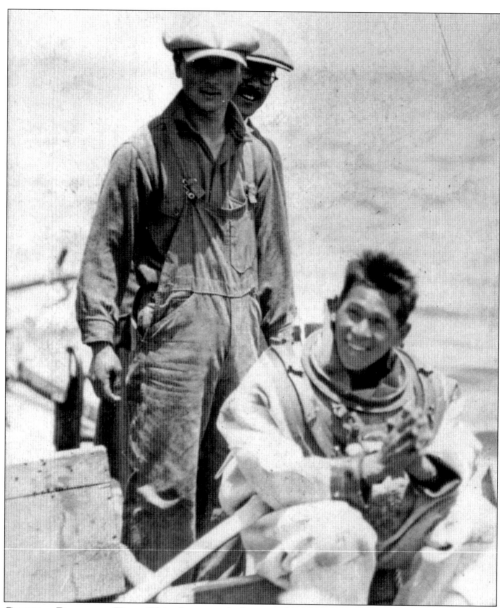

GETTING READY TO DIVE. This photograph shows a dive crew. Pictured, from left to right, are Tajuro Watanabe (standing), unidentified man behind Watanabe, and Toichiro Takigawa (diver and father of the donor of the photograph). The Japanese had a well-organized abalone industry for centuries, as it was a prized food item in Japan. In 1897, at the urging of Otosaburo Noda, who had come to Monterey a few years earlier, the Japanese government sent a young fisheries biologist by the name of Gennosuke Kodani. Kodani was so impressed with the Monterey resources that he thought something could be done with the rich fields of abalone and started a small abalone fishery along the Monterey waterfront. Kodani harvested and dried the abalone to ship back to Japan. The original Japanese Ama, or "free divers," dove down in their traditional dive gear, which consisted of a cotton suit and a pair of goggles. Because the temperature of Monterey Bay is about 15 degrees colder than in Japan, this method did not last long. (William Takigawa, donor; courtesy Monterey Public Library, California History Room.)

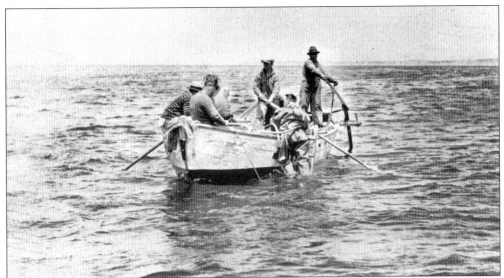

ABALONE DIVE BOAT. The Monterey dive boat was patterned after boats used at Point Lobos around 1900. The original was a recycled New Bedford whaleboat. Originally these boats used hand pumps imported from Japan, which allowed them to send air to the diver. With this pump, the diver could go down as much as 60 feet. But usually they stayed between a 15 to 20 foot depth. (William Takigawa, donor; courtesy Monterey Public Library, California History Room.)

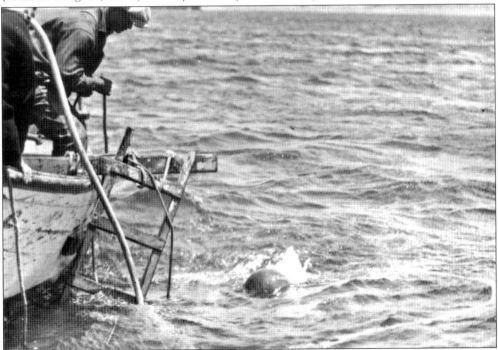

DIVE. The Japanese began experimenting with hard-hat gear, using canvas suits and the big heavy helmets. The hand-pump method was replaced with small gasoline-powered compressors in the 1920s. The diver could then spend the whole day collecting abalone. Helmet divers were brought over and initiated an abalone connection between Monterey and Japan that has lasted close to 100 years. (William Takigawa, donor; courtesy Monterey Public Library, California History Room.)

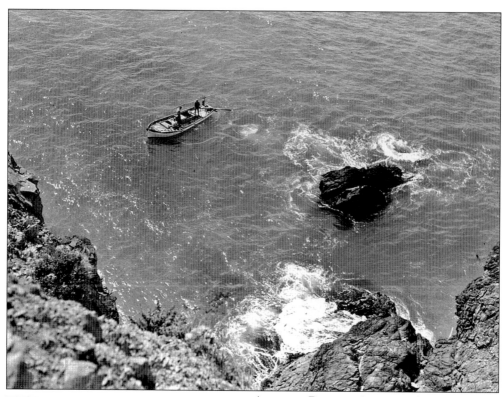

ABALONE BOAT IN ACTION. This is the only known image of a working Japanese abalone boat in action on Monterey Bay, taken around 1938. An average day for a diver in 1930 would start at 9:00 a.m. with the first dive, which lasted three hours. Returning to the surface at noon for lunch, the diving would continue with a second one at 1:00 p.m., staying down another three hours until 4:00 p.m. The large "sculling" oar on the stern was found only on Japanese boats and was used to power the boat and keep it over the diver by tracking his air bubbles on the surface while he worked the bottom. (J. B. Phillips photograph; courtesy Monterey History and Art Association.)

DIVING INTO THE BAY, 1938. Note the ladder on the port side that the diver is resting on. This was used to assist the diver in and out of the water and for the diver to lay on as the boat moved from one location to another. Note the ladder, when in the up position, points towards the stern so the diver won't be battered constantly by the waves as the boat is moving. (Rey Ruppel photograph; courtesy Monterey History and Art Association.)

"**Mother Boat.**" This large boat was known as the "mother boat." Besides pulling the small dive boat, the diver and crew lived on this boat during the abalone trips. Note the boxes on the stern, called "live boxes," which were used to keep the abalone fresh during the dive trip. (J. B. Phillips photograph; courtesy Monterey History and Art Association.)

Delivering Abalone to the Cannery on Monterey Wharf, 1938. A box on a pulley system would be dropped down to the boat for the abalone and then hauled up. (J. B. Phillips photograph; courtesy Monterey History and Art Association.)

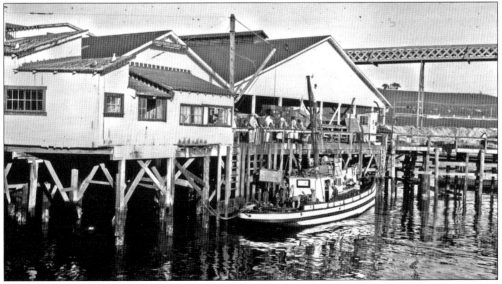

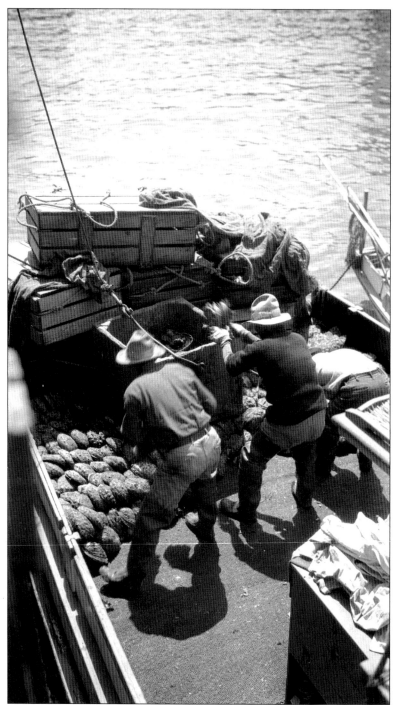

UNLOADING ABALONE AT THE MONTEREY WHARF, 1938. When this photograph was taken, there were 10 Japanese companies working out of Monterey. Abalone was fished in the spring. Each boat returned from a three-day dive, each with close to 150 dozen abalone. The fishermen received about $1.50 a dozen. The diver made a little bit more. (J. B. Phillips photograph; courtesy Monterey History and Art Association.)

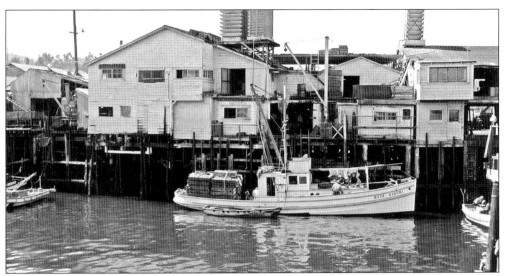

RETURN TO DOCK. A "mother boat," having returned from an abalone trip, is docked at the Monterey Wharf. Note the dive gear hanging on the boat to dry. (J. B. Phillips photograph; courtesy Monterey History and Art Association.)

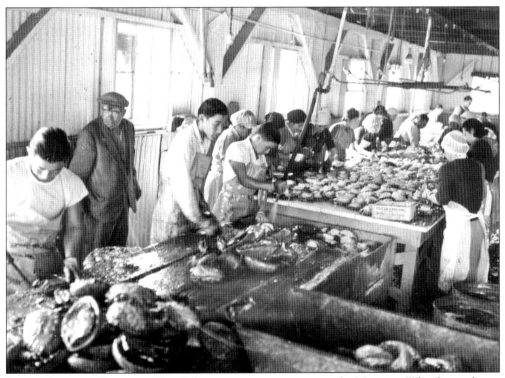

IN THE ABALONE CANNERY. The abalone canneries operating on the Monterey Wharf were almost all Japanese owned and, with few exceptions, used mostly Japanese work crews. These workers are taking the abalone out of the shells in preparation for processing. (J. B. Phillips photograph; courtesy Monterey History and Art Association.)

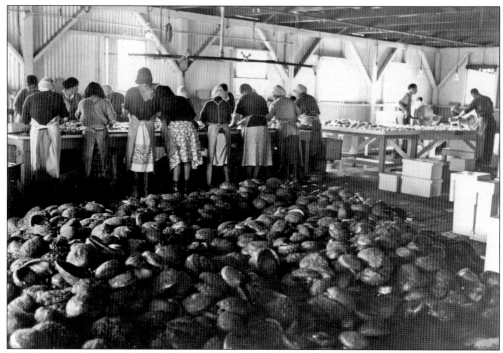

PROCESSING ABALONE IN THE CANNERY. Most of the workers in these canneries were Japanese. Look at all that abalone waiting to be processed. (J. B. Phillips photograph; courtesy Monterey History and Art Association.)

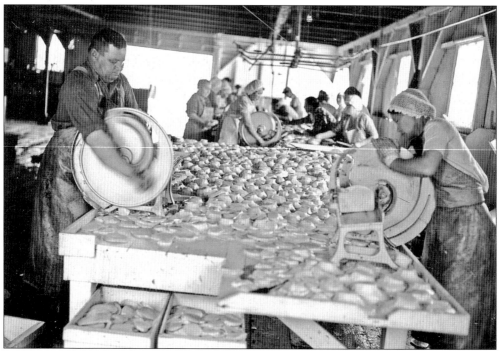

ABALONE SLICING. Workers in the Monterey Wharf cannery slice the abalone into steaks around 1938. (J. B. Phillips photograph; courtesy Monterey History and Art Association.)

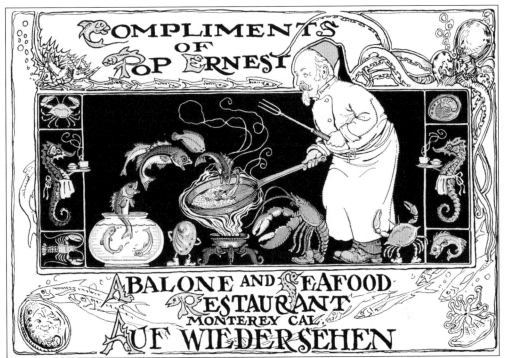

"POP" ERNEST'S MENU. Ernest "Pop" Doelter and his two sons ran an abalone restaurant on the Monterey Wharf from 1919 to 1952. Pop, a huge, outgoing restaurateur, opened a small restaurant in downtown Monterey in 1906 called Café Ernst. It was there that he first experimented with cooking Monterey red abalone and discovered the right method for tenderizing the abalone foot before cooking. Jo Mora created the menu artwork for free abalone dinners at the restaurant. (Courtesy Monterey Maritime and History Museum.)

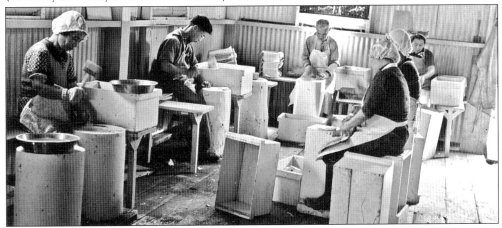

POUNDING THE ABALONE. Pop's recipe for abalone became very popular. People flocked to his establishment, which quickly became a popular hangout. Some of the locals would leave songs or poems about abalone in his guest book, such as the "Abalone Song" by poet George Sterling: "Oh! some folks boast of quail on toast/Because they think it's tony;/But I'm content to owe my rent /And live on abalone." Due to Pop popularizing abalone, he extended the Japanese abalone industry in Monterey until the beginning of World War II. (J. B. Phillips photograph; courtesy Monterey History and Art Association.)

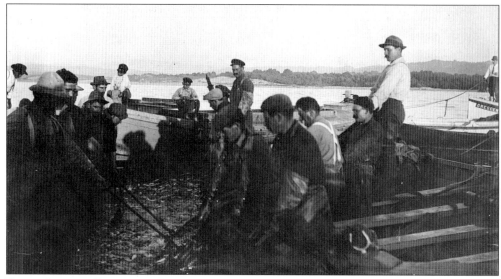

EARLY SICILIAN FISHERMEN FISHING SARDINES WITH A PURSE SEINE NET, MONTEREY BAY, 1906. By 1900, there was a great deal of anti-Japanese sentiment in the United States, particularly along the West Coast. Primarily the American workingmen feared that the Japanese would take their jobs. There was so much resentment towards the Japanese that in 1905, Frank Booth announced in the local newspaper that he would not hire any more Japanese. It was an easy call for him, considering that most of the Japanese salmon fishermen left Monterey in the fall to work in Central Valley agricultural fields. It was then that he sent for the Sicilian fishermen, who had worked for Booth on the Sacramento River, to come to Monterey and fish for sardines. (Courtesy Monterey History and Art Association.)

FRANK E. BOOTH. The pioneering fish industrialist Booth is known as the father of the modern sardine industry. (Courtesy California State Library.)

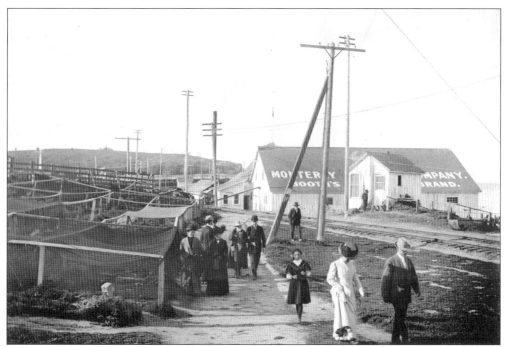

AT BOOTH'S CANNERY, 1906. In 1906, Frank E. Booth put floating pens out into the harbor so that the fishermen could keep their fish catch fresh. The problem with the pens was that all the resident seals, sea lions, and pelicans could get a free lunch. Rumsien descendant Isabel Meadows recalled that "everyone would go down to the Wharf after church to see the 'wheel of sardines.'" (Courtesy Monterey Public Library, California History Room.)

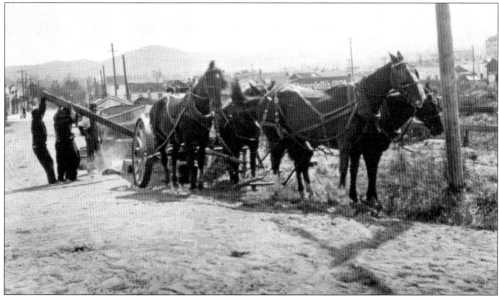

TRANSPORTING BY WAGON A BRAND-NEW LAMPARA SARDINE BOAT, 1909. Lampara refers to the type of net used in catching fish. In Sicilian, lampara means "lightning" because the action of the net was fast. Boats like this lampara were launched directly in the waves at Monterey. (Phillips Lewis photograph; courtesy Monterey History and Art Association.)

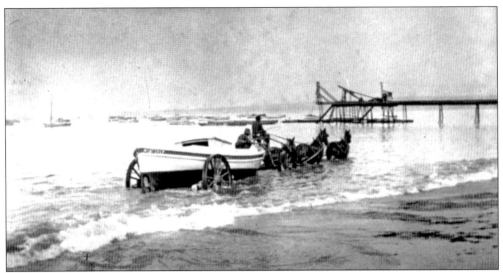

BOAT LAUNCH AT MONTEREY. This c. 1909 photograph details how the boats were actually launched by horse into Monterey Bay. (Phillips Lewis photograph; courtesy Monterey History and Art Association.)

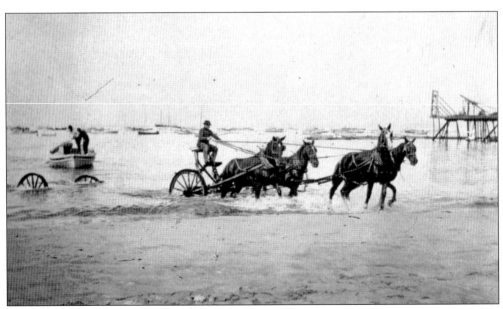

GIDDY UP! Once the boat has been launched, the driver quickly steered the wagon through the surf to shore. (Phillips Lewis photograph; courtesy Monterey History and Art Association.)

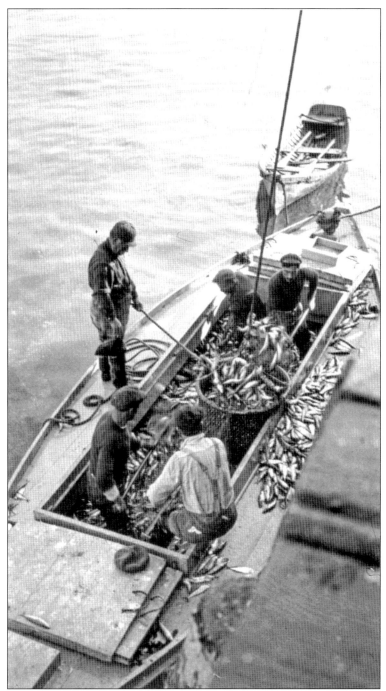

UNLOADING SARDINES AT BOOTH'S CANNERY. The boat was too small to carry the fishermen and the sardines, so a small barge called a "lighter" was used to haul fish. These early lighters could hold 25 to 30 tons of sardines. When sardines were first being fished in Monterey Bay, they were caught during the day. Fishermen would listen for a "flip in the water" that schooling fish make. Eventually the barges could hold up to 60 tons of sardines. (Phillips Lewis photograph; courtesy Monterey History and Art Association.)

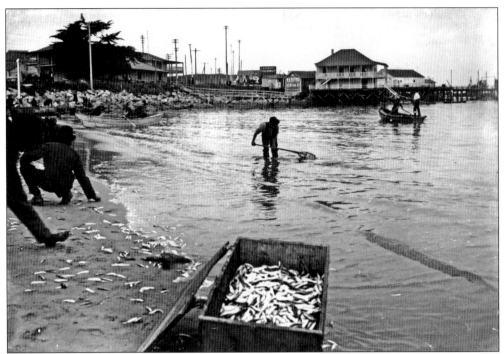

SMELT RUN, AROUND 1905–1909. There never was a large smelt fishery in Monterey. But every summer, hundreds of female smelt would swim on to the beach to lay eggs. This would usually happen in the late summer months at low tide. There has not been a smelt run in Monterey for many years. (J. K. Oliver photograph; courtesy Monterey Public Library, California History Room.)

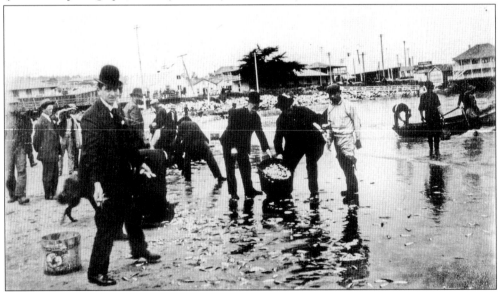

MONTEREY FEAST ON THE BEACH. Here locals collect smelt, around 1905, during one of the runs on Monterey Beach. Everyone would get in the act, including this bowler-decked man, who probably left his Alvarado Street office a bit early. The old Custom House can be seen behind the cypress tree in the background. (J. K. Oliver photograph; courtesy Monterey Public Library, California History Room.)

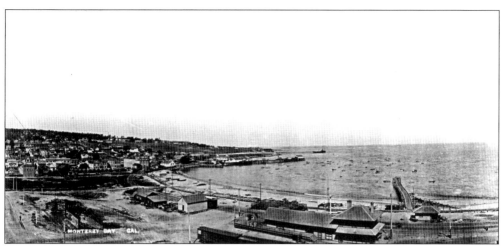

VIEW OF SHORELINE AND MONTEREY'S OLD TOWN, 1907. This panoramic view shows the wharf, built in 1875, with the express office at the shore end and the Southern Pacific train depot (in foreground). In the center is Fisherman's Wharf (also known as the Pacific Steamship Wharf at the time) and, in the distance, the Associated Oil Company wharf. (Photograph probably taken by Richard J. Arnold; courtesy Monterey Public Library, California History Room.)

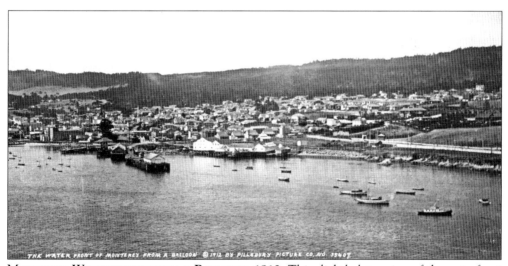

MONTEREY WATERFRONT FROM A BALLOON, 1912. This slightly later view of the waterfront shows the development of Fisherman's Wharf and the Booth Cannery complex near the foot of the wharf, which was due to the rapidly growing fishing industry. Booth leased the property from the city, knowing that he had to expand to compete with other canners. (Pillsbury Picture Company photograph; courtesy Monterey Public Library, California History Room.)

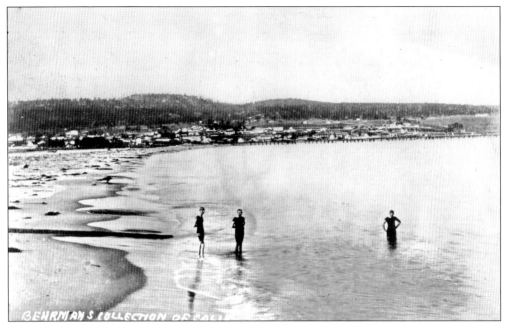

EARLY MORNING SWIMMERS, FEBRUARY 7, 1883. Among the many uses and attractions of the Monterey waterfront was beach and shoreline swimming. The establishment of the Hotel del Monte's bathhouse increased the recreational use of the waterfront. (Isaiah W. Taber photograph; courtesy Monterey Public Library, California History Room.)

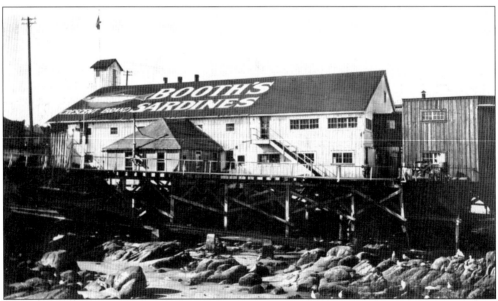

BOOTH'S CANNERY VIEWED FROM THE WHARF AROUND 1910. Note the Crescent brand logo on the roof of the building. In 1904, Booth paid 75 employees and the next year hired Norwegian fisheries expert Knut Hovden. Booth's process became increasingly mechanized with Hovden's improvements. By fall 1910, Booth was ready for more innovation and expansion. (Courtesy Monterey Public Library, California History Room.)

Six

FISHERMAN'S WHARF AND THE "NEW WHARF"

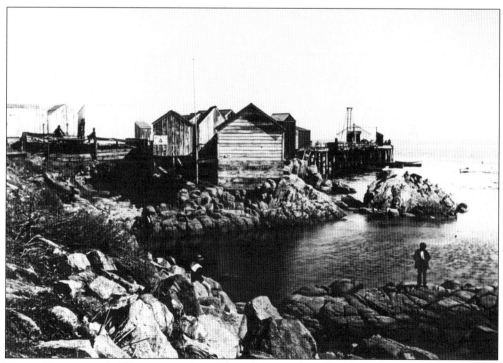

EARLY FISHERMAN'S WHARF, C. 1900. This photograph was taken when the wharf was part of the Pacific Steamship Company Lines and relied on the lumber trade. The Monterey fishing industry was still in its infancy. (J. K. Oliver photograph; courtesy Monterey Public Library, California History Room.)

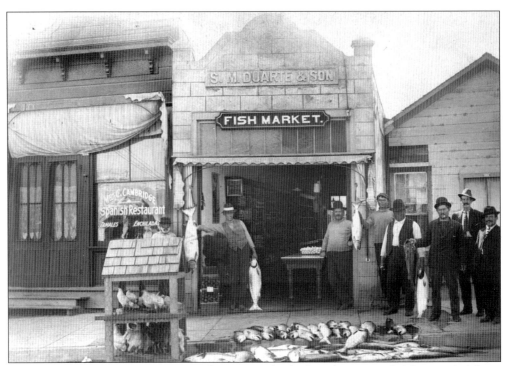

DUARTE'S FISH MARKET, C. 1900. The Duartes had a long history with Monterey's fishing industry. Operating fish markets, fishing supply stores, boat rentals, glass-bottom boat rides, and even chickens, the family offered various services. Each of the Duarte brothers was involved in the business. Manuel, Esperion, Lewis, and Santa Maria sold fish and curios and leased boats. At one time, they had a fleet of 20 fishing boats. (Courtesy Monterey Public Library, California History Room.)

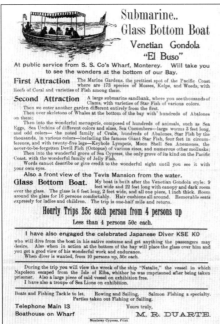

DUARTE'S FOURTH OF JULY FLYER, 1910. Among the sights to behold on a trip aboard Manuel Duarte's glass-bottom boat, *El Buso*, was "a wonderful menagerie composed of hundreds of animals, such as sea eggs, sea urchins of different colors and sizes, hundreds of abalone, star fish by the thousands!" As a further attraction, he "engaged the celebrated Japanese Diver K. Seko, who will dive from the boat in his native costume." (Courtesy Heritage Society of Pacific Grove.)

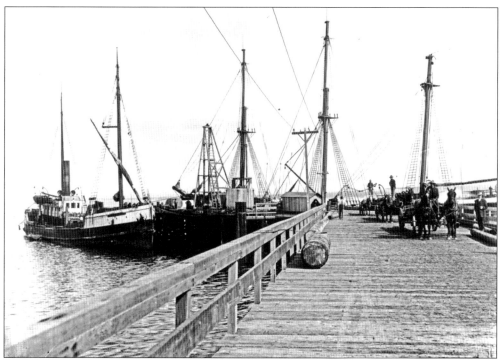

LUMBER SCHOONER AT THE MONTEREY WHARF. Note the horse-drawn wagon hauling lumber, c. 1900. (J. K. Oliver photograph; courtesy Monterey Public Library, California History Room.)

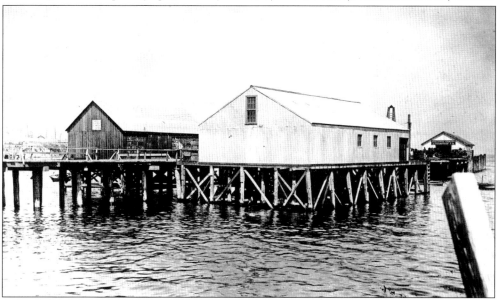

MONTEREY WHARF AROUND 1909. This early view of today's Fisherman's Wharf shows the original freight building, Pacific Coast Steamship, in the distance. Booth's warehouse is on the right. Merchant Thomas O. Larkin built the original Monterey Wharf (actually a pier) in 1845. Early entrepreneurs like Larkin and other merchants and ship captains wanted to insure that their cargoes were transported safely to land from visiting ships. (Probably F. C. Swain photograph; courtesy Monterey Public Library, California History Room.)

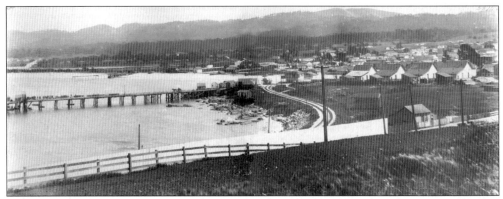

PANORAMIC VIEW OF MONTEREY AND ITS WHARF, 1903. This photograph reveals H. R. Robbins's early salmon packing plant, cannery, dance hall, and smokehouse, built on beachfront property next to the wharf and the Custom House. It opened for business in 1901. (Courtesy Monterey Public Library, California History Room.)

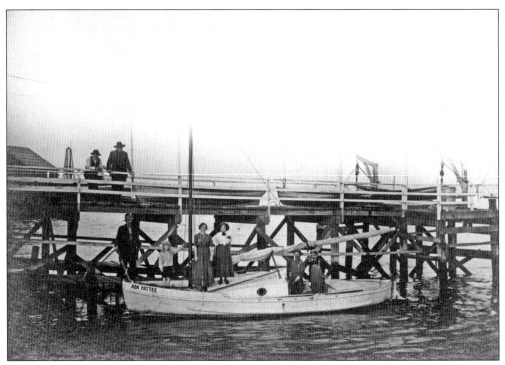

ADA PATTEE. An early pleasure craft is docked at the wharf. On a beautiful Sunday, people would often engage a boat for a ride on the bay. (F. C. Swain photograph; courtesy Monterey Public Library, California History Room.)

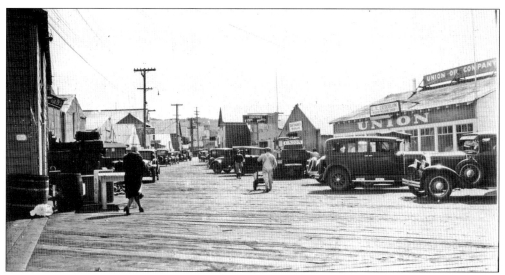

FISHERMAN'S WHARF, 1935. During the heyday of commercial fishing, several hundred market fisherman brought in daily catches of salmon, albacore, mackerel, rockfish, lingcod, squid, and abalone. Fish-processing companies and markets produced a beehive of activity. (Courtesy J. B. Phillips photograph; Monterey History and Art Association.)

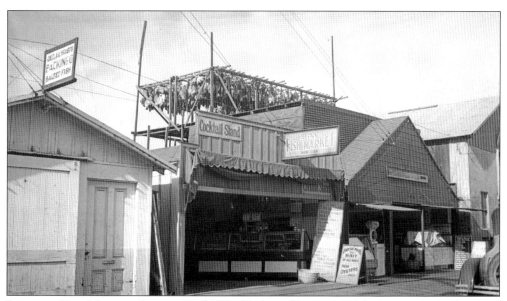

JAPANESE FISH MARKET. Prior to World War II, about 80 percent of the businesses on the wharf were owned and operated by Japanese. Note the drying racks for fish on the roof. (J. B. Phillips photograph; courtesy Monterey History and Art Association.)

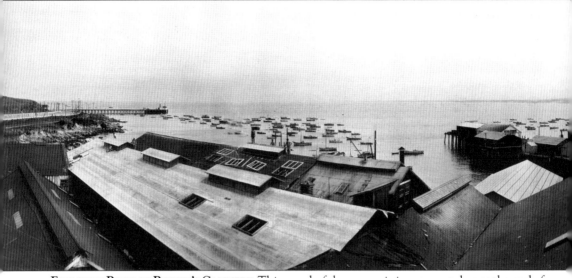

FROM THE ROOF OF BOOTH'S CANNERY. This wonderful panoramic image was taken at the end of the salmon season in 1919. Those are mostly salmon boats in the water. Fisherman's Wharf began over 100 years ago when it was built by the Pacific Steamship Company, whose steam schooners plied up and down the California coast with passengers and cargoes of lumber, tanbark, canned fish, and occasionally Chinese squid. The City of Monterey took over the wharf during the early

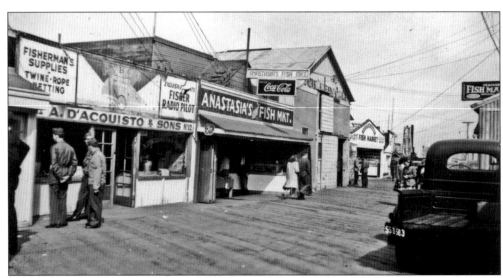

MONTEREY WHARF, FEBRUARY 1946. By the 1940s, the number of fish markets and tourist attractions had increased on the wharf, and the patrons of the wharf began to change. Note the soldiers from either the Presidio of Monterey or nearby Fort Ord visiting the wharf. (William L. Morgan photograph; courtesy Monterey Public Library, California History Room.)

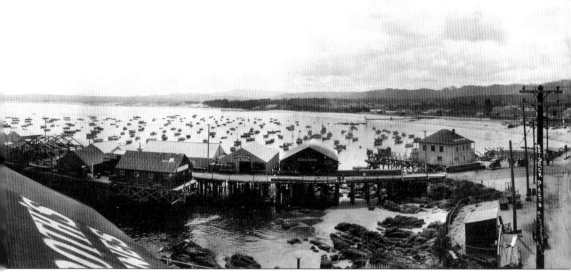

fishing industry. The old wharf became the headquarters for the wholesale fish shippers and the sardine fishing fleet. The wharf at far right is for the Hotel del Monte and Bathhouse. There was a wooden sidewalk that took people from the hotel all the way to the foot of the Monterey Wharf. (A. C. Heidrick photograph; courtesy Monterey Public Library, California History Room.)

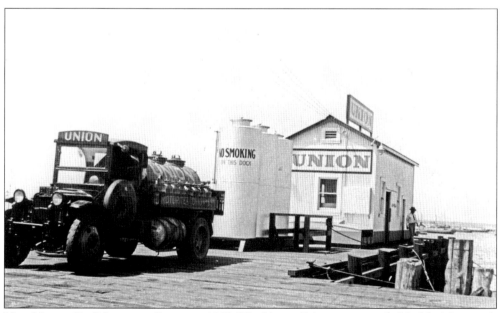

NEW UNION OIL MARITIME STATION, 1932. The Union Oil station provided fuel for Monterey's sardine fishing fleet. (John Napoli, donor; courtesy Shades of Monterey collection, Monterey Public Library, California History Room.)

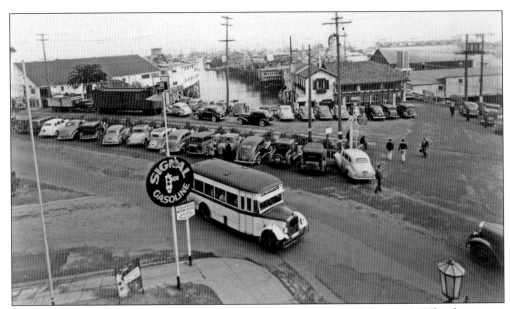

ENTRANCE TO FISHERMAN'S WHARF, 1935. This is a view of the Fisherman's Wharf entrance from the roof of the Custom House. Booth's expanded cannery is the building at left. Note the rail boxcar and truck in front of the cannery for shipping sardines. At this time, Fisherman's Wharf was still a working wharf supporting the Monterey sardine industry. (A. C. Heidrick photograph; courtesy Monterey Public Library, California History Room.)

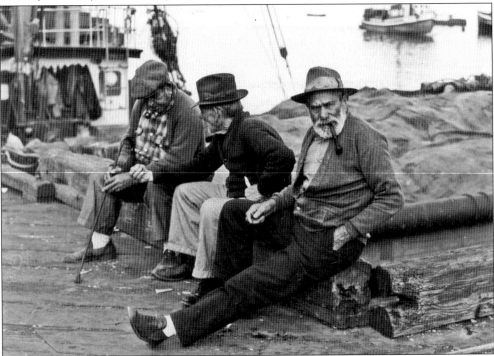

DAYS OF YORE. Three "old-timers" reminisce about their days fishing on the Monterey Bay in this October 1940 photograph. (William L. Morgan photograph; courtesy Monterey Public Library, California History Room.)

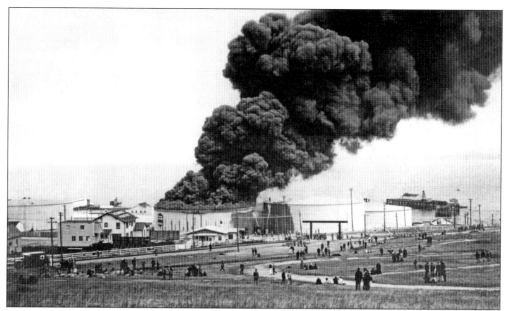

THE OIL FIRE. On September 14, 1924, a lightning bolt struck one of the 55,000-gallon storage tanks of the Associated Oil Company. Oil, piped from Coalinga, California, to Monterey, was stored in the oil tanks located near Cannery Row and the Monterey Wharf. Three soldiers from the Presidio at Monterey—Sergeant Beans, Corporal Evans, and Private Bolio—who volunteered to fight the fire, lost their lives. (C. K. Tuttle photograph; courtesy Monterey Public Library, California History Room.)

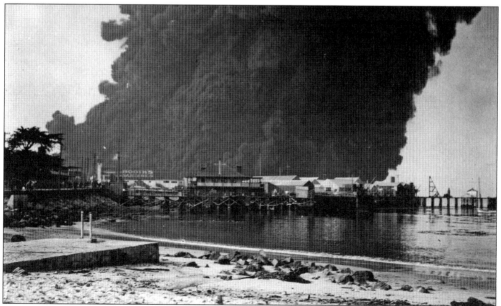

FIRE THREATENS THE WHARF. The fire was so intense that it burned for three days, eventually brought under control about 72 hours after it started. A group of Monterey fishermen saved the Monterey Wharf and Booth's Cannery by building a firebreak in the harbor. The financial loss was estimated to be about $1.5 million. This photograph shows just how close it came to destroying Fisherman's Wharf. (Courtesy Pat Sands.)

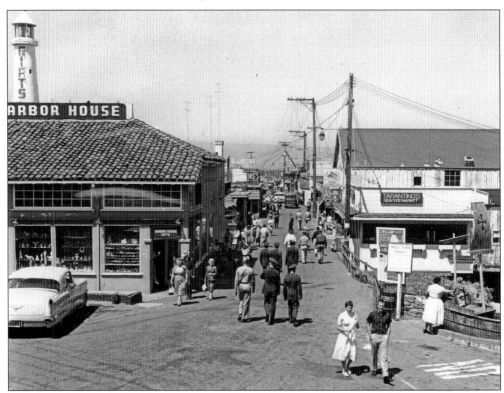

ENTRANCE TO FISHERMAN'S WHARF, MAY 1958. After the collapse of the Monterey sardine industry, the wharf shifted from a working fishing wharf to one that catered to the tourist. At left is the old Pilot House Restaurant, and at right is Tarantino's and other seafood restaurants. (Lee Blaisdell photograph; courtesy Monterey Public Library, California History Room.)

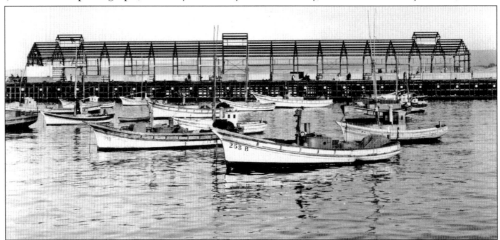

THE NEW WHARF BEGINS, 1926. By the mid-1920s, it was clear that the current Monterey Wharf could not support the growing Monterey fishing fleet. A new wharf was needed. Construction of the wharf took place from 1925 to 1927. In 1927, Municipal Wharf No. 2 opened for business. Today the wharf remains a real working structure where commercial fishing boats unload. It is still called the "new wharf" by old-timers. (A. C. Heidrick photograph, Wharf Album; courtesy Monterey Public Library, California History Room.)

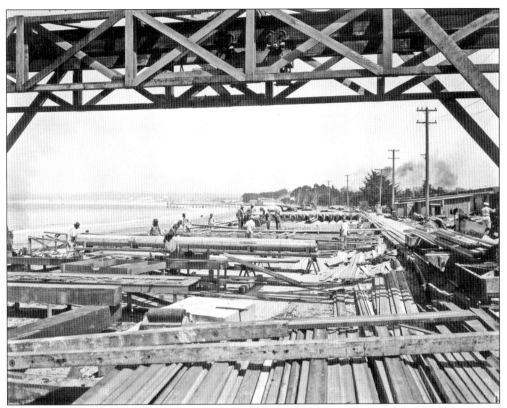

BUILDING THE WHARF. This April 25, 1926, view shows workmen working on Monterey Beach. In the distance can be seen the Del Monte Bath and pier. (A. C. Heidrick photograph, Wharf Album; courtesy Monterey Public Library, California History Room.)

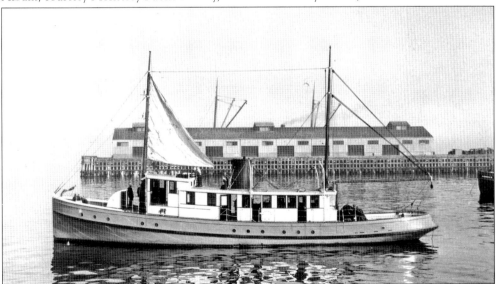

THE "NEW WHARF" RIGHT AFTER COMPLETION. The boat directly in front of the wholesale fish warehouse is a California Fish and Game research vessel. (A. C. Heidrick photograph, Wharf Album; courtesy Monterey Public Library, California History Room.)

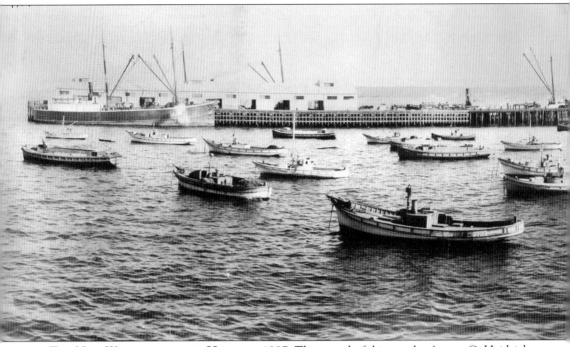

THE NEW WHARF FROM THE HARBOR, 1927. This wonderful image by Anton C. Heidrick, a local photographer, combines two key ingredients of Monterey's booming sardine industry in the 1920s: the lampara fishing fleet and the necessity for a new working wharf and fish warehouse.

FIRST FREIGHTER. Monterey residents and visitors crowded the new wharf to see the first freight steamer to dock, the *Robin Goodfellow*, pictured here on March 18, 1928. The *Robin Goodfellow* brought lumber and picked up cases of Monterey sardines. (A. C. Heidrick photograph; courtesy Monterey Public Library, California History Room.)

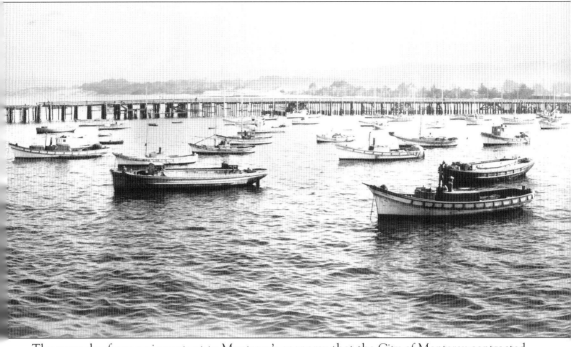

The new wharf was so important to Monterey's economy that the City of Monterey contracted with Heidrick to visually document its construction and opening. (A. C. Heidrick photograph; courtesy Monterey Public Library, California History Room.)

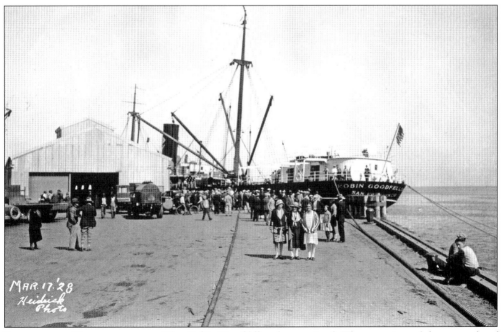

LADIES AND GENTLEMEN . . . The *Robin Goodfellow* has arrived. The opening of the new wharf took place with fanfare. The arrival of the *Robin Goodfellow* became a new tourist attraction in 1928. (A. C. Heidrick; courtesy Monterey Public Library, California History Room.)

UNLOADING BULL KELP AT THE NEW WHARF. In the early 1930s, there was a fishery for the bull kelp, which was then the dominant kelp in Monterey Bay. Fishermen, using long knives on a pole, cut the kelp. It was then hauled to the wharf, ground up, and shipped to the East Coast for use in dyes for synthetic silk. (J. B. Phillips photograph; courtesy Monterey History and Art Association.)

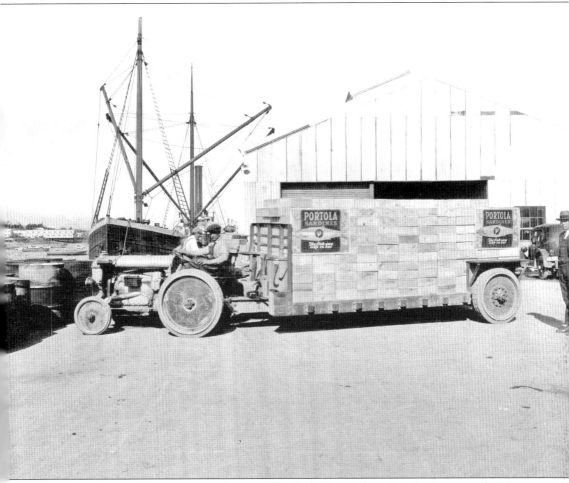

SARDINES READY FOR SHIPMENT. Boxes of Hovden's Portola brand sardines are trucked from the cannery to the wharf for shipment on the *Crescent City*, the coastal freighter seen at left. Even though the railroad accounted for most of the domestic sardine shipments, canneries still relied on ships for all oversea shipments. On the left is the San Carlos Cannery. (A. C. Heidrick photograph; courtesy Monterey Public Library, California History Room.)

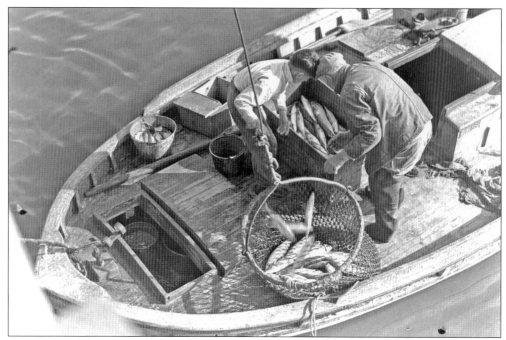

UNLOADING MACKEREL AT THE NEW WHARF. In this 1937 photograph by Julian P. Graham, mackerel fishermen transfer their catch to the wharf. (Courtesy Monterey Public Library and Terry L. Anderson and Barbara Briggs-Anderson.)

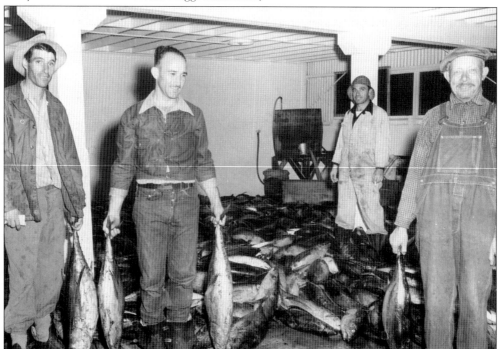

MACKEREL AND MORE MACKEREL. Inside General Fish, the wholesale fish dealer located at the end of the wharf, a mackerel catch is sorted and displayed on October 8, 1947. (William L. Morgan photograph; courtesy Monterey Public Library, California History Room.)

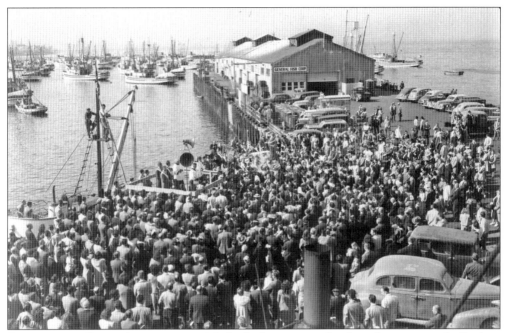

BLESSING THE FLEET, SEPTEMBER 1946. At the beginning of each sardine season, the Sicilian community would hold the Santa Rosalia Festival, which included the official blessing of the fishing fleet and its fishermen for a safe and bountiful harvest. All the boats were decorated and open to the community to visit. The festival continues today, and food and music are available for all. (William L. Morgan photograph; courtesy Monterey Public Library, California History Room.)

SANTA ROSALIA, 1950. The highlight of the festival would be the blessing of the fleet and the carrying of the statue of Santa Rosalia from San Carlos Church to the wharf. Fishing families would "pin" money to Santa Rosalia for good fortune in the coming fishing season. (William L. Morgan photograph; courtesy Monterey Public Library, California History Room.)

ON THE "NEW WHARF." This is the cork line, or top of the net, used for a purse seine in September 1936. The net is being readied for piling on the purse seine boat. (William L. Morgan photograph; courtesy Monterey Public Library, California History Room.)

WEEKEND FISHING. Here people fish for smelt off the new wharf around 1930. (J. B. Phillips photograph; courtesy Monterey History and Art Association.)

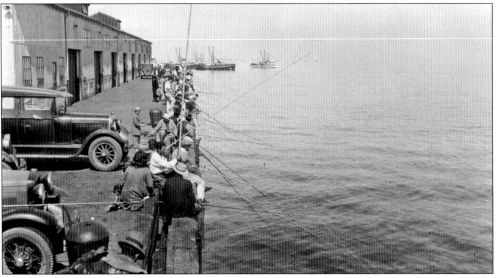

SOUSED MACKEREL? The first national ad for Monterey sardines appeared in a Sears and Roebuck catalogue in 1905. Being advertised is Booth's "Soused Monterey Mackerel." Sardine is actually a generic word for small fish. In California, and all along the West Coast, fishermen catch what is known as a pilchard—the true sardine. When Booth first began canning them, he found them too big and not saleable, so he first advertised them as "Soused Monterey Mackerel." (Courtesy Monterey Maritime and History Museum.)

AERIAL VIEW OF THE MONTEREY HARBOR. The two Monterey wharves and their importance to Monterey's fishing industry can be seen here, as well as the fishing fleet of September 1946. (William L. Morgan photograph; courtesy Monterey Public Library, California History Room.)

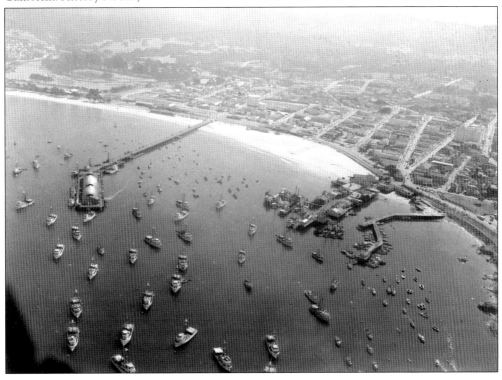

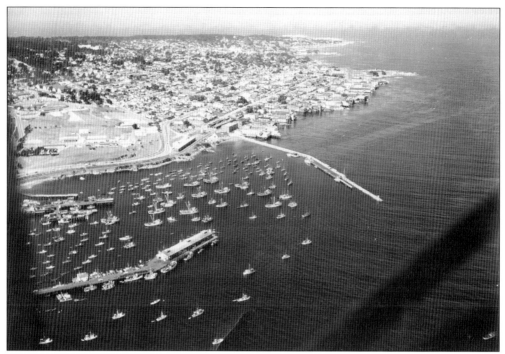

ANOTHER BIRD'S-EYE VIEW OF THE MONTEREY HARBOR. In this photograph, the immensity of the Monterey fishing fleet can be seen. At one time, the sardine fishery supported well over 100 boats. This photograph was taken exactly 10 years later than the one on the previous page and shows the breakwater and, to the right in the distance, Cannery Row. (Lee Blaisdell photograph; courtesy Monterey Public Library, California History Room.)

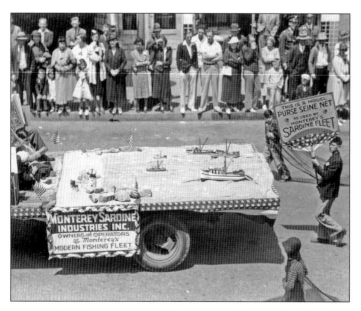

A MONTEREY PARADE. During the 1938 Fourth of July parade, the Monterey Sardine Industries union offered this model of sardine purse seiners in action. The city of Monterey was very proud of its fishing industry, and it was always prominently showcased in any city event. Note the kids trailing behind the float with the nets and a sign. They are children of Monterey fishermen. (William L. Morgan photograph; courtesy Monterey Public Library, California History Room.)

Seven

SARDINES
AND CANNERIES

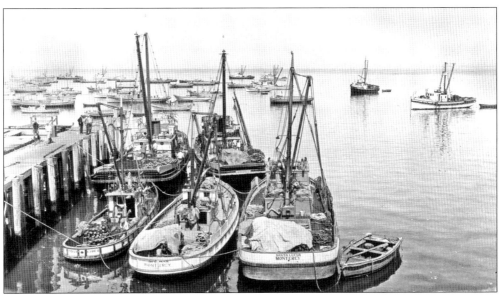

PAST, PRESENT, AND FUTURE. This is Monterey's past, present, and future in the fishing industry in 1930. The three boats in the foreground, from left to right, are a lampara, a ring boat or Japanese round-haul, and a new purse seiner (referring to the type of net used). In the background are two new purse seiners with turntables for the net. The purse seiner first made its appearance on the Monterey Bay in 1926. The fishermen in Monterey were resistant to move to these big boats primarily due to the cost. The lampara, fully rigged and ready to go in 1930, cost about $6,000. A new purse seiner, fully rigged and ready to go, cost about $30,000, not including the net, which was another $10,000 to $15,000. Eventually most fishermen used the big purse seiners. They obtained loans from the diesel-engine companies and from the Bank of Italy, now the Bank of America. (J. B. Phillips photograph; courtesy Monterey History and Art Association.)

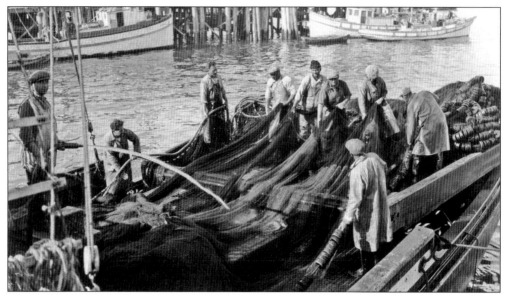

NETS. The net was the most important tool on the boat. Here are some Monterey fishermen washing their nets after a day on the water around 1939. (J. B. Phillips photograph; courtesy Monterey History and Art Association.)

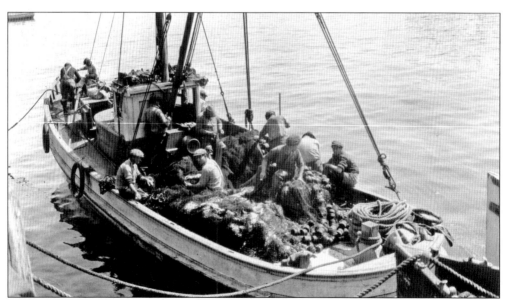

LAMPARA BOAT AROUND 1930. Note that there are 14 fishermen on this boat. There's no cabin space or place to go if it's raining, and there are no radios or fish finders. Fishing boats also pulled a barge called a lighter for holding all of the caught fish. (J. B. Phillips photograph; courtesy Monterey History and Art Association.)

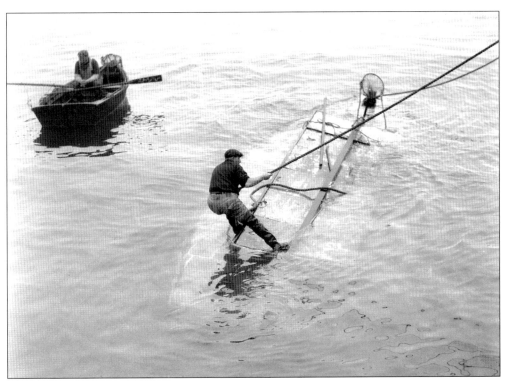

SARDINE LIGHTER. This fully loaded—actually overloaded—small sardine lighter holds a catch and is trying to keep afloat so the crew can unload after a night's fishing. There is probably close to 40 tons of sardines on that barge. (Courtesy Julian P. Graham Historic Photograph Collection, Loonhill Studios.)

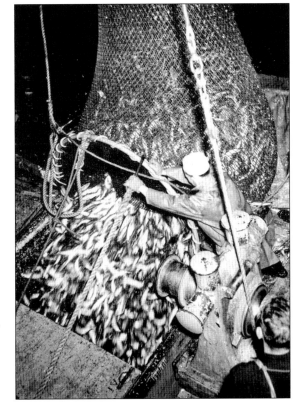

SILVER HARVEST. This man is working hard pouring sardines into the hold of a purse seiner. Right away the advantage to using the purse seiner can be seen as there is no barge to pull. Some of these boats could hold up to 100 tons of sardine, or 150 tons with a deck load. They also had cabin space with a galley, bunks for rest, and, on some boats, even showers. (J. B. Phillips photograph; courtesy Monterey History and Art Association.)

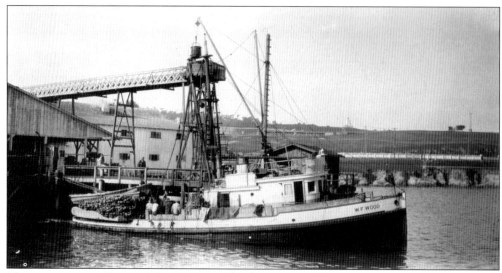

UNLOADING THE CATCH. The *W. F. Wood* is being unloaded at Booth's Cannery in January 1930. Sitting low in the water, the boat has a full load. A bucket, which holds 600 pounds of sardines, was dropped into the boat's hold. It was then pulled up to the weight room for weighing. Finally the sardines were moved by conveyer belt into the cannery for processing. (J. B. Phillips photograph; courtesy Monterey History and Art Association.)

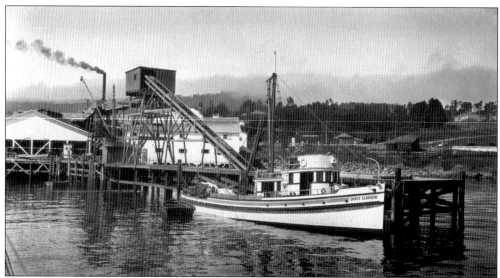

DANTE ALLIGHERI. This boat, owned by the Colletto family, is unloading at Booth's Cannery in August 1930. Note how the cannery has grown in six months. Booth added a fish ladder for easy unloading. Fishermen were paid by weight and negotiated the price of fish per ton with the canneries at the beginning of each and every season. (J. B. Phillips photograph; courtesy Monterey History and Art Association.)

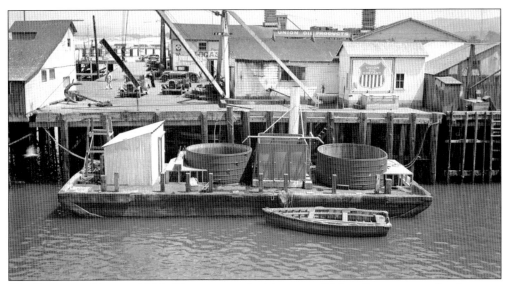

NET-TANNING BARGE, 1930. The nets on the Monterey fishing fleet were made of cotton, which had to be treated with a tannic acid solution to protect them. Bark from a tan oak tree was boiled to release its natural tannic acid. (J. B. Phillips photograph; courtesy Monterey History and Art Association.)

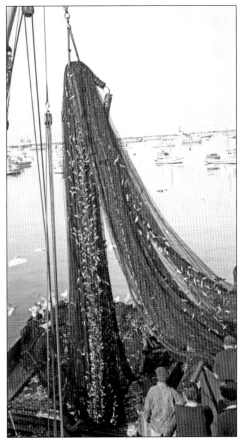

"CHRISTMAS TREE." This net is full of anchovies. Fishermen called it a "Christmas tree" because it reminded them of a star-studded Christmas tree when pulled up with all the silvery shining anchovies. They were first called Christmas trees in the early 1930s when Monterey fishermen caught a large number of anchovies around Christmas time. (J. B. Phillips photograph; courtesy Monterey History and Art Association.)

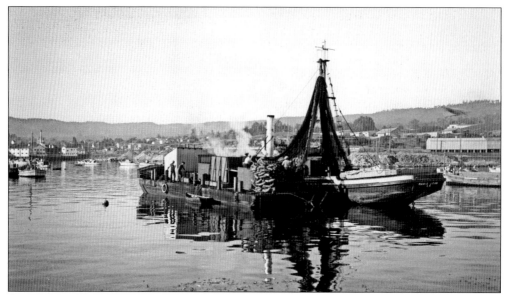

TANNIC ACID BARGE AT WORK ON MONTEREY BAY. This barge was developed because sardines would oftentimes run with other schooling fish like anchovies. Anchovies were trouble for the fishermen because they are smaller than sardines and would get caught by their gills in the net and have to be handpicked out. They also secrete mucus that can ruin a $15,000 net. This method was short-lived when it proved not to save any time. (J. B. Phillips photograph; courtesy Monterey History and Art Association.)

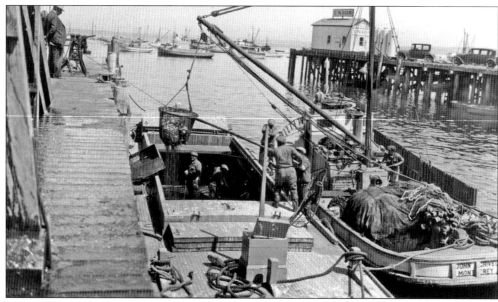

MONTEREY LAMPARA AND LIGHTER UNLOAD AT BOOTH'S CANNERY, 1930S. This barge held up to 60 tons of sardines. If full, it could take five to six hours to unload, often after fishing all night. (J. B. Phillips photograph; courtesy Monterey History and Art Association.)

UNLOADING AT THE SARDINE HOPPER, C. 1938. When first used, purse seiner boats were found too large to unload sardines at the canneries. Knut Hovden, having worked in Norway's fruit and vegetable fields with hoppers, designed a new system of anchoring the fish hopper in the bay and attaching two flotation tanks to the bottom about 500 feet from each cannery. A marine pump sent the sardines in the hopper directly through steel pipes to the canneries. (J. B. Phillips photograph; courtesy Monterey History and Art Association.)

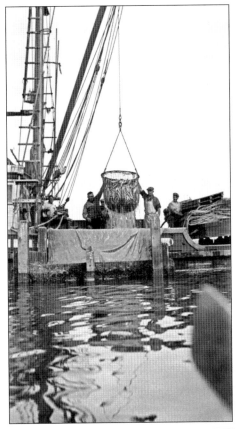

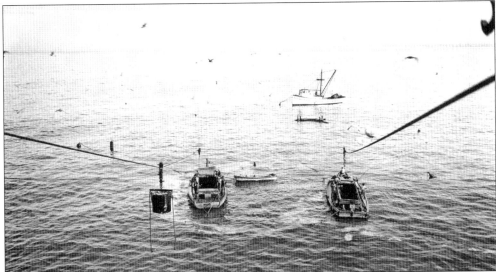

TWO SARDINE LIGHTERS UNLOAD AT HOVDEN'S CANNERY AROUND 1930. There were fishermen who never moved to the big purse seiners and continued to use the smaller lampara and lighter. The cannery dropped a bucket by cable to the barge to unload. Each bucket could hold 600 pounds of sardines. When there are 60 tons of sardines to unload, this could be a very slow system. (J. B. Phillips photograph; courtesy Monterey History and Art Association.)

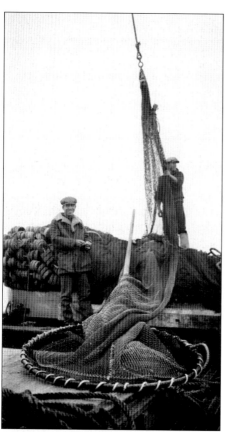

BRAILING NET. This is a brailing net that is used with a wench to lift the fish out of the hold of the boat and into the hopper. (J. B. Phillips photograph; courtesy Monterey History and Art Association.)

MONTEREY FISHERMEN REPAIRING THEIR NETS. Because sardines feed on a small phosphorescent animal, they are fished at night at the "Dark of the Moon." Sardine season in Monterey lasted from August 1 to February 15. Fishermen fished six nights a week, except Saturday and the two nights before a full moon and the two after, as it was too bright to fish. It was during this time that the boats and nets were repaired. (Courtesy Monterey Public Library, California History Room.)

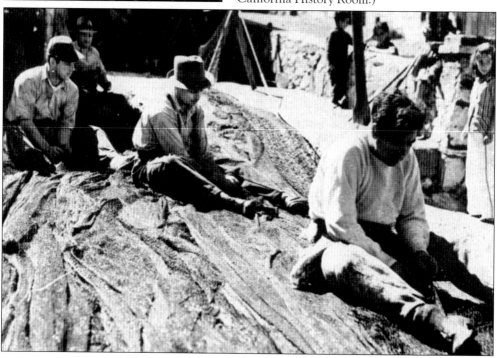

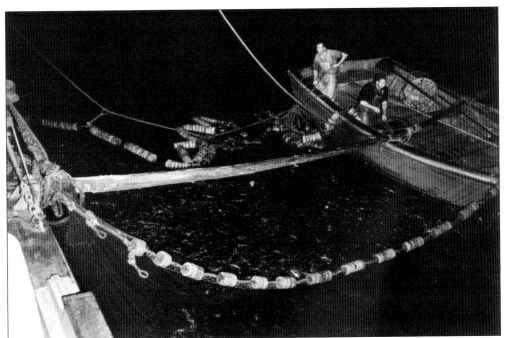

NIGHT WORK. Spotting a sardine school, fishermen put a skiff into the water. Holding one end of the net, the skiff moves clockwise while the big boat moves counterclockwise, circling the sardines and dropping the net around them like a big fence. Pulling up the net with a mechanical wench, the net was closed at the bottom like a purse. Netted and hoisted, sardines were "brailed" into the boat's hold. (Courtesy Monterey History and Art Association.)

TRUCKING. By 1950, there were fewer and fewer sardines, and the fishermen were going further and further out to catch them. This photograph was taken at Santa Barbara where Monterey sardine fishermen were catching fish. The Monterey canneries would truck the sardines back to Monterey. The sardine fishery in Monterey and along the West Coast was the largest fishery of a single fish in the history of the United States. It lasted only 35 years. (J. B. Phillips photograph; courtesy Monterey History and Art Association.)

UNLOADING TRUCKED FISH AT HOVDEN'S CANNERY ON CANNERY ROW. Fish were put in a hopper, then transported up the fish ladder into the cannery for processing. (J. B. Phillips photograph; courtesy Monterey History and Art Association.)

END OF THE ROAD. The trucking system never worked well. One reason was that the fish could not be kept fresh over the long ride back to Monterey. This photograph shows the end of an experiment. (J. B. Phillips photograph; courtesy Monterey History and Art Association.)

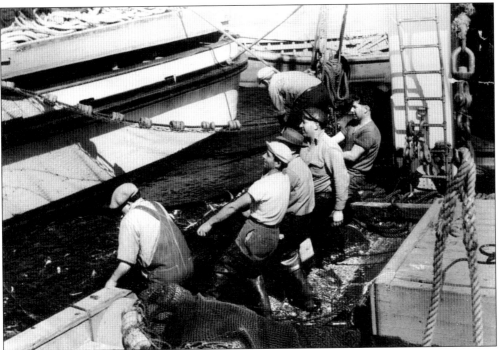

THE GOOD YEARS. The years 1939 to 1942 produced large sardine catches at Monterey. The fishing fleet brought in over 248,000 tons of sardines valued at over $4 million. In this 1939 photograph, the crew of the *City of Monterey* transfers sardines from the over-full *California Rose*. (Courtesy Monterey Public Library, California History Room.)

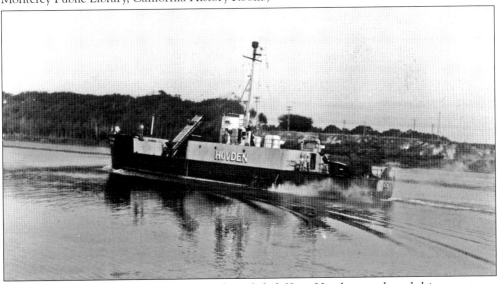

MONTEREY'S TITANIC. After sardine trucking failed, Knut Hovden purchased this army troop landing craft and, at great expense, converted it into a floating sardine cannery. His idea was to have the floating cannery meet the fishermen in the fishing grounds and begin the canning process as it returned to Monterey. This image is of the *Hovden* on its one and only voyage—Monterey's version of the *Titanic*. The *Hovden* proved financially unsuccessful and sunk. (J. B. Phillips photograph; courtesy Monterey History and Art Association.)

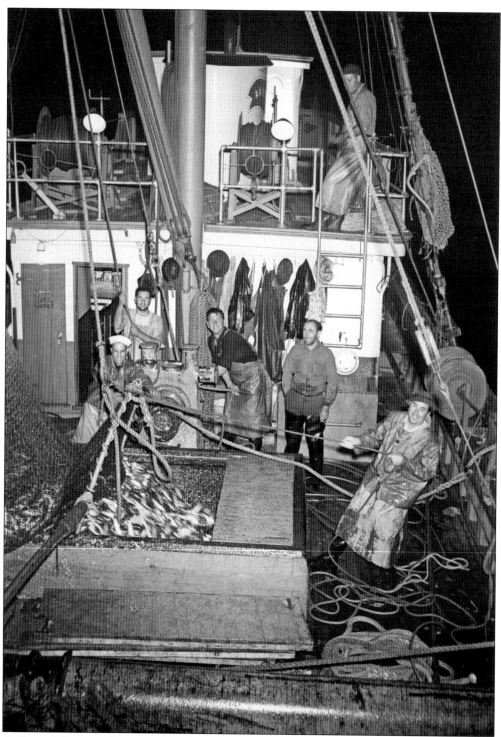

A Good Night of Fishing Sardines on the AA Ferrante, 1948. These fishermen are looking forward to a good payday after successful "Dark of the Moon" fishing. (J. B. Phillips photograph; courtesy Monterey History and Art Association.)

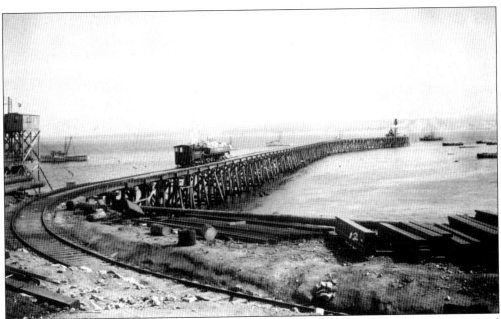

BUILDING THE MONTEREY BREAKWATER. Monterey and its fishing fleet had been hit and damaged repeatedly by storms coming from all directions. For years, fishermen pressed the city to build a breakwater to protect the fishing fleet. On Thanksgiving Day in 1919, Monterey was hit by a massive storm that wiped out 50 percent of the fleet. Finally Monterey constructed the breakwater from 1932 to 1934. The breakwater's chief booster, one-time Monterey mayor and civic activist Harry A. Greene, became known as "Breakwater Harry." (A. C. Heidrick photograph; courtesy Monterey Public Library, California History Room.)

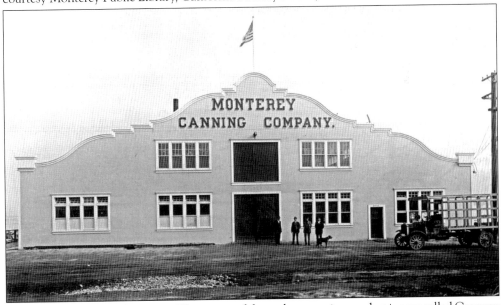

MONTEREY CANNING COMPANY. This is one of the early canneries on what is now called Cannery Row. Built in 1918, owners A. M. Allan and George Harper stand in front of the new building. Unusual for most canneries, the facade displayed a Mission Revival style of architecture. (Courtesy Monterey Public Library, California History Room.)

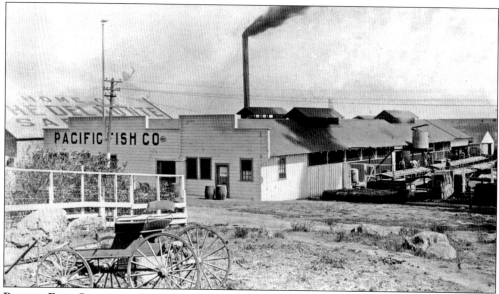

PACIFIC FISH COMPANY, 1909. In a highly competitive business, cannery names and owners changed frequently. Pacific Fish was originally the Monterey Fishing and Canning Company, the first canning/packing plant on Cannery Row, which was started in 1902 by Harry Malpas and Otosuburo Noda. Pacific Fish became the first major cannery on the Row. In 1926, California Packing Corporation bought it. (Courtesy Monterey Public Library, California History Room.)

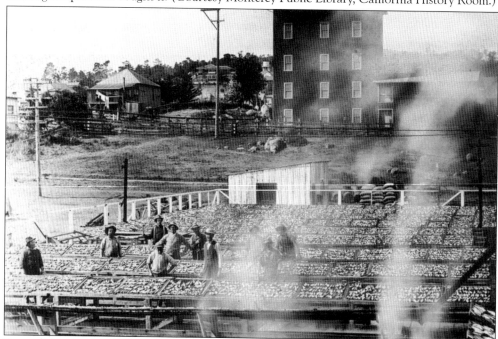

DRYING SARDINES. In the earliest days of the sardine canneries, almost everything was done by hand. The fish were brought in by baskets and laid out on big racks to dry in the sun before moving to the cannery to have the heads and tails cut off, have its offal removed, and then go through the cooking process. Every can was hand-soldered. Early sardine canning was a slow process. (Courtesy Monterey Public Library, California History Room.)

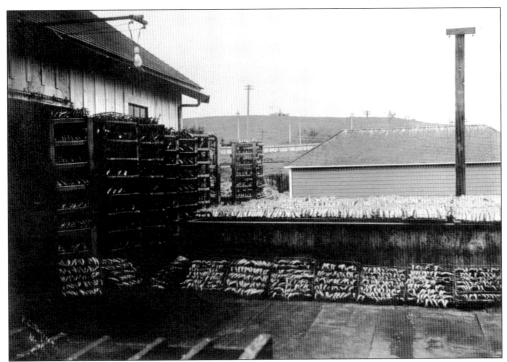

THE FRENCH METHOD. This is an early view of drying sardines at Booth's Cannery. Before 1920, sardines were cooked in hot oil like French fries. It was called the French method. (Courtesy Monterey Public Library, California History Room.)

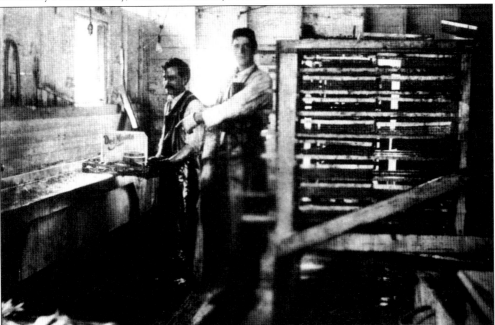

DEL MONTE BRAND. This is what it looked like inside the Pacific Fish Company in 1909. Note the racks of sardines and the simple, hands-on processing. (Amelie Kneass Elkinton, donor; courtesy Monterey Public Library, California History Room.)

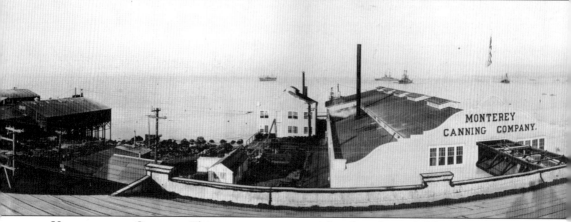

VIEW FROM THE CANNERY. This panoramic view was taken from the roof of the Monterey Canning Company. Note the U.S. Navy's Pacific Fleet in the harbor during a visit to Monterey in August 1919. In the distance, Carmel Canning Company can be seen. Near the flag is a glimpse of the edge of Pacific Fish Company. At the sardine industry's peak, there were 19 canneries operating at any given time. This photograph was taken at the beginning of the Monterey sardine season.

WORKER SHANTIES. By 1919, nine canneries operated on the Monterey waterfront with several hundred workers. Since cannery work was seasonal, many of the workers did not live in Monterey full time. These "worker shacks" were provided at a low rent to house them. Note the abalone shells hanging on the porch. The City of Monterey has preserved three of the shacks along the "chicken walk" to the canneries. (Courtesy Monterey Public Library, California History Room.)

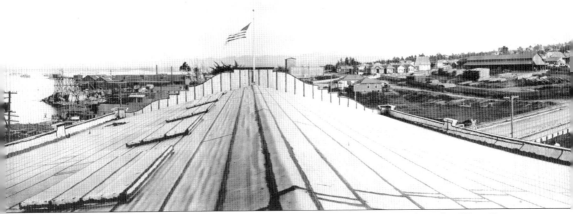

A strike of Pennsylvania steelworkers cut off the tin supply being shipped to the West Coast. Without tin, it is impossible to make cans. And without cans, sardines can't be packed. Thus the canneries shut down and workers and fishermen were laid off. Eventually the steelworkers' strike was settled and everyone went back to work, but the sardine workers began to think about unions. (A. C. Heidrick photograph; courtesy Monterey Public Library, California History Room.)

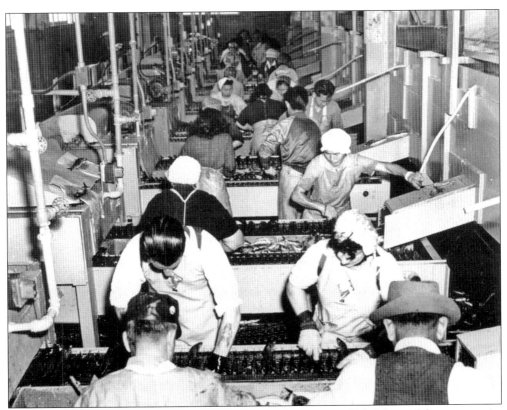

JAPANESE FISH CUTTERS INSIDE THE SAN XAVIER CANNERY, 1930. Many of these canneries had a multicultural workforce. The "forelady," the woman in charge of all the women workers, had to speak enough words in different languages, such as Japanese, Chinese, Italian, Portuguese, and Spanish, to supervise her line workers. (Courtesy Tom Fordham.)

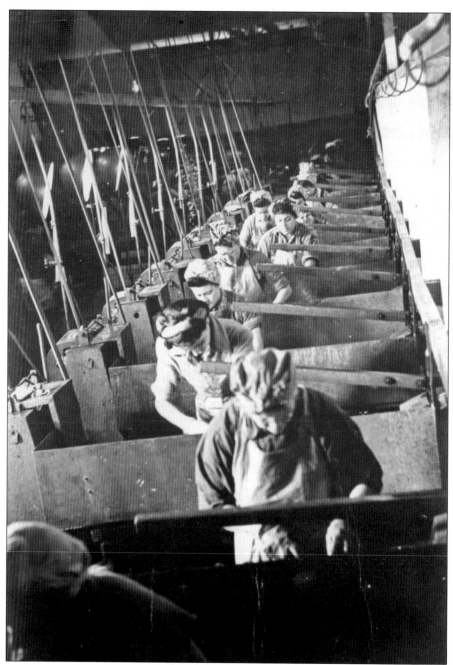

WOMEN CANNERY WORKERS. Prior to World War II, a man was never seen working on the canning lines. If there were not enough women, the lines were shut down, as it was considered "women's work." Most people went to work when the boats came in, sometimes at 2:00 or 3:00 a.m., and cannery workers usually lived nearby. Each cannery had its own method for calling their workers to the cannery; many had whistles with a distinct sound. At the season's height, a person worked 10 to 12 hours a day, six days a week, and did not go home until all the fish had been put up. It was loud, cold, and wet in these canneries. At times, the workers would be standing in a foot of water. (Courtesy Monterey Public Library, California History Room.)

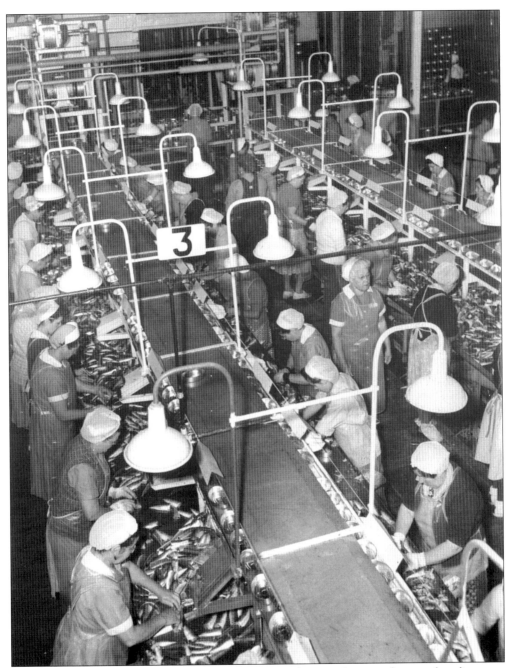

CAL PAC CANNING LINE. The women in this *c.* 1949 photograph are packing oval sardine cans at the California Packing Corporation (known as "Cal Pac"), part of Del Monte Foods, while a forelady walks the lines. The women working the lines were paid by the piece. In 1939, at the peak of the sardine industry, a female worker canning sardines would make 23¢ for every 16 cans she put up. In some canneries, the worker had a card pinned to her back to keep track of how many cans she put up. The forelady walked the line every hour marking the cards. During World War II, Ed Ricketts worked briefly as a scientist in this cannery. (George Robinson photograph; courtesy Monterey Public Library, California History Room.)

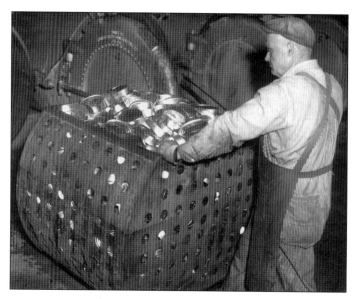

BOILER MAN, 1940s. The men who worked in the canneries often ran the boilers or worked in the warehouse. They also made about 15¢ more an hour than the ladies. Sardines are cooked in the can by steam under low pressure. Beginning around 1921, the canneries started to use steam to cook the sardines as opposed to the deep-frying method. It was faster, safer, and cleaner. (Rey Ruppel photograph; courtesy Monterey Public Library, California History Room.)

SPIKING THE CANS WITH TOMATO SAUCE, 1940s. Note this man's union buttons on his hat. Although sardines were sold for food, the real money was not in the canned sardines but in the by-products. Reduction was the process rendering the offal and other waste products into fertilizer, oil, meal, and chicken feed. The reduction process was simple, requiring less than five employees to run the plant, and it was very profitable. (Rey Ruppel photograph; courtesy Monterey Public Library, California History Room.)

TIME OUT. After work, it was time for cannery workers to relax. Many workers would bring parts of their own cultural music and food to the cannery to share in an impromptu recital. (Fred Harbick photograph, Muriel Pyburn collection; courtesy Colton Hall Museum, City of Monterey.)

END OF AN ERA. The sardine fishery collapsed after 1950—not because of overfishing, although it played a minor role. Other major factors were involved. Recent research shows that sardines and anchovies run in 30- to 40-year cycles, and their disappearance is a natural occurrence. When the sardine fishery in California grew in 1915, the sardine was already in the early stages of its decline, and the fishery just sped up that natural process. There were also environmental issues and changes in the water temperature that eventually contributed to its collapse. After the collapse, Cannery Row became a ghost town. A person could roll a bowling ball down the middle of the street and not hit anything. (J. B. Phillips photograph; courtesy Monterey History and Art Association.)

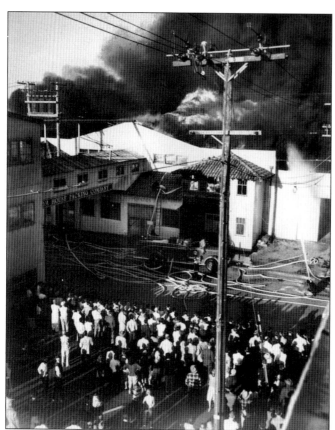

CANNERY FIRE. Soon after the sardine collapse, mysterious fires broke out and burned many of the abandoned canneries down. This is a photograph of the October 1953 fire at Custom House Packing Company on Cannery Row. (Lee Blaisdell photograph; courtesy Monterey Public Library, California History Room.)

RELICS OF THE ROW. Much of the cannery equipment was sold and sent to South America where a new sardine fishery developed. But just like Monterey, it eventually collapsed as well. (J. B. Phillips photograph; courtesy Monterey History and Art Association.)

Eight

SCIENTISTS OF
CANNERY ROW

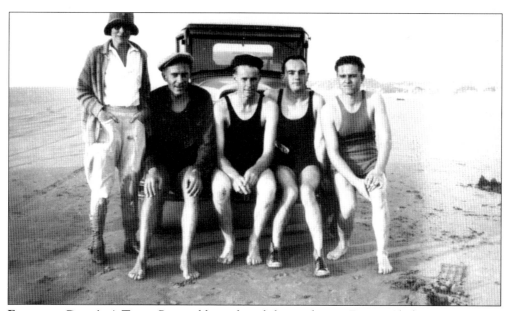

FISH AND GAME'S A-TEAM. Pictured here, from left to right, are Francis Clark, W. L. Scofield, Richard Crokar, M. J. Linar, and J. B. Phillips. In 1919, the California Department of Fish and Game opened an office at Hopkins Marine Station, near what is now the Monterey Bay Aquarium, to monitor the rapidly growing sardine fishery. For the first 10 years, they collected samples from each cannery and kept catch records from the fishermen. Because of this early research, Fish and Game declared on April 15, 1930, that unless canneries slowed down and took smaller catches, the sardine fishery would eventually collapse. No one listened. Clark was the first person to receive a doctorate in Fish and Game. Beginning as the librarian, she later managed all of Fish and Game's sardine programs. (N. B. Scofield photograph; courtesy Monterey History and Art Association.)

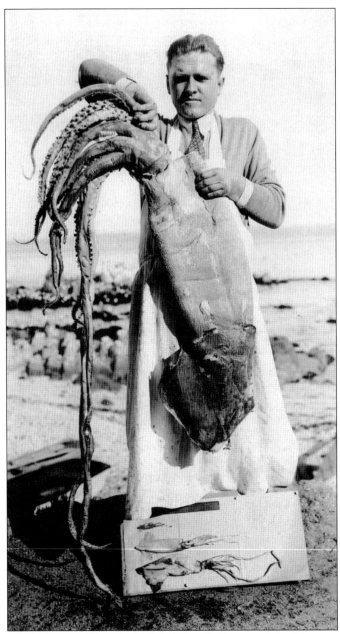

JULIUS'S SQUID. Over the next 20 years, Fish and Game monitored the Monterey fishery, adding more aggressive programs. This photograph of Fish and Game marine biologist Julius "Julie" B. Phillips, holding a giant squid, was taken in 1930 at Hopkins Marine Station. In the summer of 1928, Phillips, fresh out of the University of Washington School of Fisheries, was summoned to Monterey to begin work with the California Department of Fish and Game. The summoning letter stated that the sardine canneries would be opening soon and his presence was needed. Thus began a remarkable 40-year career that ended with his retirement in 1968. During his tenure, he authored or coauthored over 75 scientific publications. He made significant contributions to the knowledge of numerous marine species, including sardines, anchovies, lingcod, Dungeness crabs, sablefish, and rockfishes. (Rolf Bolin photograph; courtesy Monterey History and Art Association.)

SEA OTTER STUDY. In this c. 1930 photograph, a little-known Fish and Game exercise program for young sea otters seems to be taking place. (J. B. Phillips photograph; courtesy Monterey History and Art Association.)

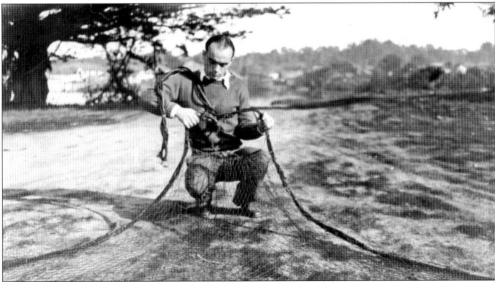

TECHNOLOGY RESEARCH. A Fish and Game scientist holds a lampara net around 1930. Fish and Game would buy fishing gear to better understand how it worked. Oftentimes they were able to improve the equipment, making it easier for the fisherman. (J. B. Phillips photograph; courtesy Monterey History and Art Association.)

SARDINE-TAGGING. In 1935, Fish and Game began a sardine-tagging program. Scientists obtained sardines from the fishermen and inserted, using a scalpel, a small, numbered, metal tag into the fish. They were then released back into the water. Each reduction plant was equipped with a 50-pound magnet that captured these small tags. This enabled Fish and Game to tell where and when sardines were being caught. Those released in Monterey could have been caught a year later in San Diego, or sardines released in the Pacific Northwest would be caught in Monterey. (J. B. Phillips photograph; courtesy Monterey History and Art Association.)

RESEARCHING THE SARDINE. This scientist stands on the deck of a Fish and Game research vessel. Because of the sardine tagging, Fish and Game announced in 1939 that the sardine fishery needed to be cut in half. Again no one listened. In 1939, when asked, "Where are all the sardines?," senior biologist Francis Clark replied, "They're all in cans." (J. B. Phillips photograph; courtesy Monterey History and Art Association.)

TWO FISH AND GAME BIOLOGISTS WITH AN OCTOPUS TRAP. In the early 1920s, a Sicilian fishermen known as "Two Pipes" or "Old Man Giannini" used these baskets to catch large "spot" prawns in Monterey Bay. Two Pipes plied the waters between Monterey and Carmel. Salting the bay with his baskets, he weighed them down with rocks and laid them on their side, coming back to retrieve them later in the day. Secretive about his methods, he never used floats or markers in fear that other fishermen would discover his fishing grounds. Soon other Monterey fishermen used these baskets, primarily to catch large octopus. The fisherman baits the baskets with live crab tied at the narrow end of the funnel. The octopus swimming into the funnel to get the crab became trapped. By the mid-1930s, Monterey was the largest West Coast port for giant octopus. (J. B. Phillips photograph; courtesy Monterey History and Art Association.)

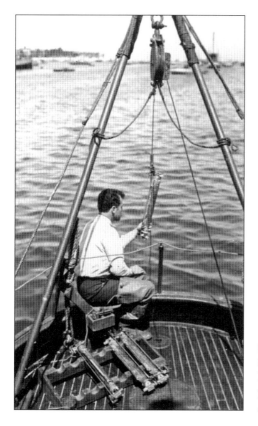

SAMPLING THE BAY. This is a Fish and Game scientist taking water samples on Monterey Bay in the early 1930s. (J. B. Phillips photograph; courtesy Monterey History and Art Association.)

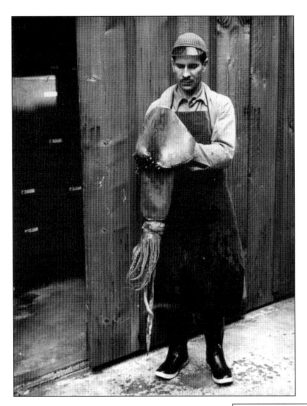

ED RICKETTS AND THE GIANT SQUID. Ricketts operated Pacific Biological Laboratories, a marine biological specimen supply house on Cannery Row. Ricketts also pursued scientific research on the ecology of the intertidal zone, as well as various marine species. He authored *Between Pacific Tides* with Jack Calvin and the *Log from the Sea of Cortez* with John Steinbeck. (Ralph Bauschbalm photograph; courtesy Vicki Pearse.)

FROG HUNT. Ricketts was a model for the character Doc in Steinbeck's *Cannery Row.* Although fictional, the novel drew on some real people and incidents. In the novel, Mac and the Boys set out on a frog-hunting expedition. This is a permit sent to Ricketts from California Fish and Game giving one of the "boys" permission to collect frogs and lampreys in the Carmel and San Joaquin valleys. (Edward F. Ricketts Papers; courtesy of the Monterey Public Library, California History Room.)

Nine

THE ABALONE KING, BASKING SHARKS, AND SQUID

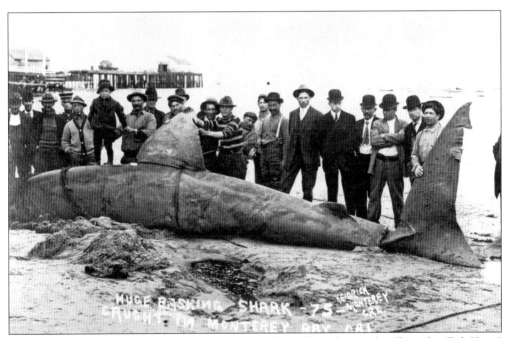

FISH KING. In 1908, Monterey fisherman Luis Perez (far left) was known locally as the "Fish King." Perez was fishing one day for rockfish when he accidentally caught a basking shark. He brought this strange animal to the Monterey Wharf where his friend Manual Duarte, who ran a small fishing store catering to tourists, thought they could make some money. The partners soon put up a small tent on the beach next to the Monterey Wharf, placed the shark inside, and charged 50¢—a good sum in 1908—just to look at a dead shark. According to the Monterey newspaper at the time, the shark was exhibited for 10 days. (A. C. Heidrick photograph; courtesy Monterey History and Art Association.)

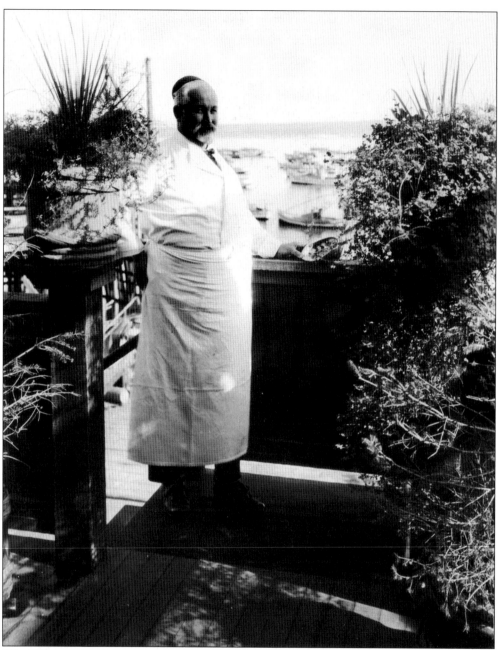

"Pop" Ernest Doelter—the Abalone King. "Pop" stands on the porch of his restaurant on Monterey Wharf. In the summer of 1924, Pop and his friend Henry Leppert, a Monterey blacksmith, teamed up to find a new and creative way to advertise Pop's abalone restaurant. Their idea was to take guests from the Hotel del Monte on excursions in Pop's brand-new, 40-foot abalone boat, the *Pop Ernest*, where for 50¢ they could harpoon a basking shark. For some unknown reason, beginning in the early 1920s, basking sharks came into Monterey Bay in very large numbers, sometimes in the hundreds. These sharks, a nuisance to fishermen, often became tangled in their nets. At that time, there was not a market for the basking shark, so Pop and Henry came up with this idea of taking tourists out to harpoon them for sport. (Courtesy Pat Sands.)

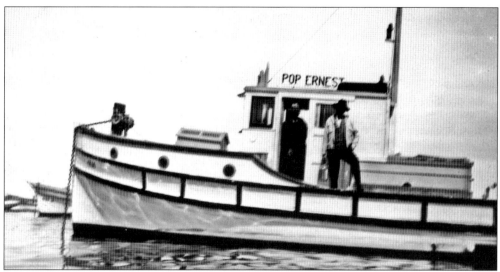

POP ERNEST'S ABALONE AND BASKING SHARK BOAT, AROUND 1925. Still living in Monterey were a number of retired Portuguese whalers. Pop arranged to have these whalers come out on his boat to demonstrate how to throw the harpoon and to tell their tails of whaling on the Monterey Bay. (Courtesy Pat Sands.)

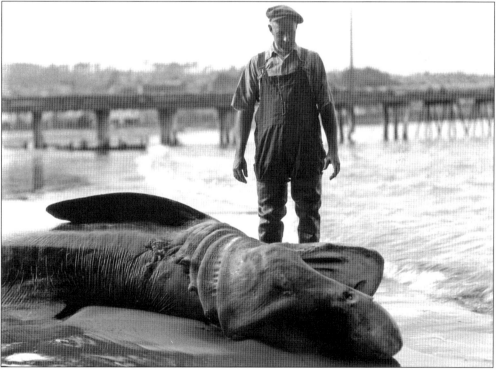

BASKING SHARK DANCE. Because the main purpose of the *Pop Ernest* was collecting abalone, she had an air compressor on board for the divers. Often, after the kill of a basking shark, Henry Leppert would pump the carcass of the animal with air and then spin it until it was belly-up. He would then get on the dead shark's belly and dance for all the customers. It was a highlight of the trip. (Courtesy Julian P. Graham Historical Collection, Loonhill Studios.)

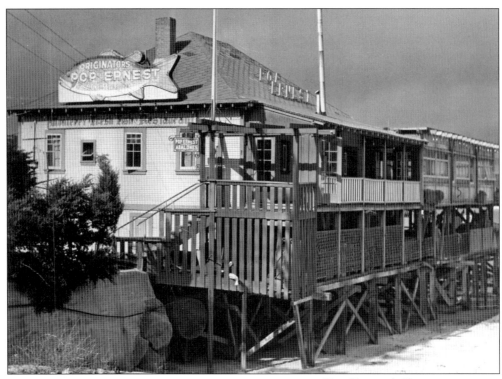

POP ERNEST'S RESTAURANT. Pop's restaurant was located at the foot of the Monterey Wharf, the former Monterey Boat Club building. Pop died in 1934, but his two sons continued to run the business until 1952, when they sold the restaurant. Here Pop had popularized abalone and served other seafood fare. (Julian P. Graham photograph; courtesy Monterey Public Library, California History Room.)

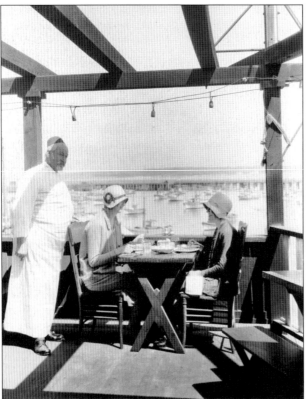

DINING AT POP'S. Pop talks to two diners on the deck of his restaurant overlooking the Monterey Bay. The two women diners are eating Pop's famous abalone stew that he served in the actual abalone shell. He filled the holes of the shells with lead. (Courtesy Pat Sands.)

BERT KORF AND FAMILY. By 1925, other companies began to offer basking shark hunts on the bay, in particular, Bert Korf and Chester Gilkey, owner-operators of the boat *Two Brothers.* Although the partners did not offer old whalers as guides aboard their boat, they did have Thomas Machado, son and grandson of Monterey Portuguese whalers. They charged only 25¢ to harpoon a basking shark. (William L. Morgan photograph; courtesy Monterey Public Library, California History Room.)

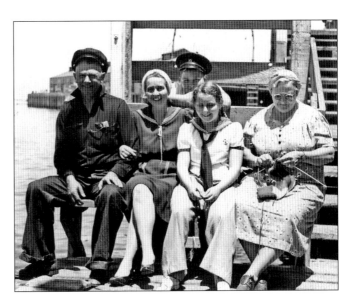

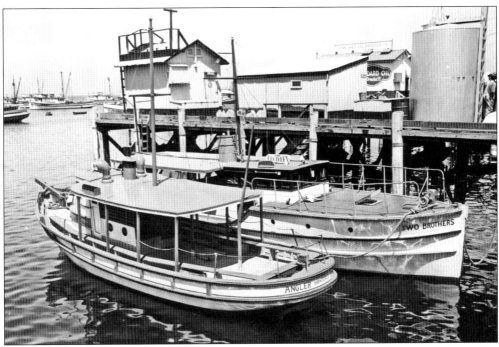

TWO SPORT BOATS AT FISHERMAN'S WHARF. The boat closest to the wharf is the basking shark boat *Two Brothers.* When the basking shark fishery first started in 1924, it was strictly for sport. Beginning in 1927, sardine businessman Max Schaefer owned a small plant in the sand dunes of nearby Seaside. Noticing all the basking shark activity offshore, Schaefer started buying the shark carcasses from fishermen. His plan was to grind them up for dog and cat food and use the oil from the livers for a product he called "Sun Shark Liver Oil." (Courtesy Lee Harbick collection, Monterey Public Library, California History Room.)

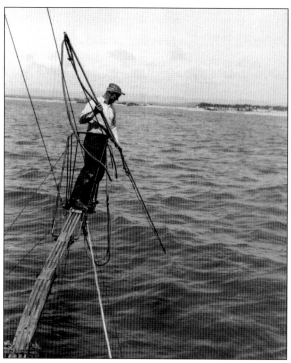

FREEMAN "WHITEY" ARBO, BASKING SHARK FISHERMAN. "Whitey" Arbo is perched and getting ready to harpoon a shark around 1948. (J. B. Phillips photograph; courtesy Monterey History and Art Association.)

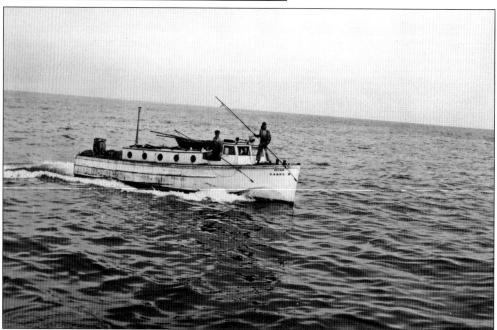

THE TWO BROTHERS. The boat was a converted 50-foot navy motor sailor and could take several passengers at a time. Because this was a tourist-generated industry, the owners were always looking for new ways to entertain their customers. From time to time, Burt or Chester would jump on the back of the shark and ride it like bucking broncos at the rodeo. Unfortunately for the rider, the basking shark's skin is very rough, almost like little teeth, and usually tore the rider's legs. (J. B. Phillips photograph; courtesy Monterey History and Art Association.)

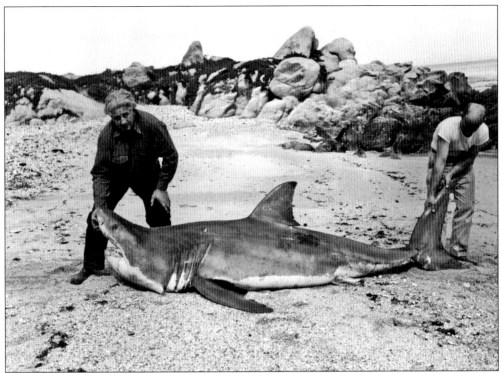

ANOTHER KIND OF SHARK. Two basking shark fishermen, Bill Tomlesen (right) and his partner Jack Daniels, return with a bonus—a great white shark. (Courtesy Pat Sands.)

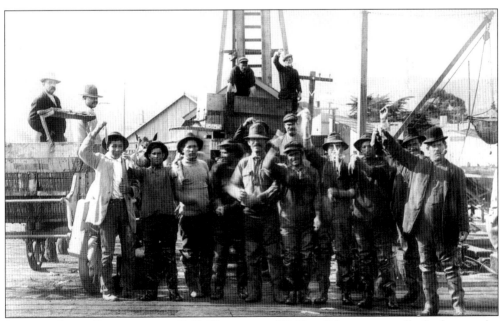

SICILIAN SQUID FISHERMEN, C. 1915. This group of Sicilian fishermen proudly display samples of their squid catch on the Monterey Wharf. (Courtesy Monterey Public Library, California History Room.)

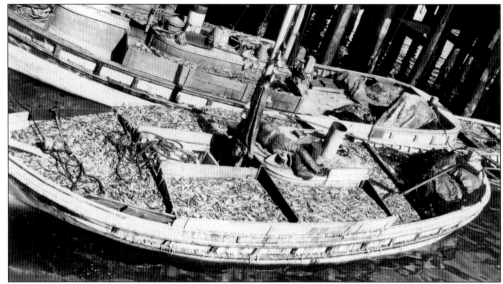

SQUID HARVEST. When Sicilian fishermen first came to Monterey in 1905, they brought with them the lampara, which means lightning in Sicilian. The lampara net was used primarily to fish sardines but in the spring, when there were no more sardines, they fished for squid. At that time, squid was considered a junk fish, which none of the canneries wanted, so the Sicilians sold it to the Chinese. Note the fisherman sound asleep on his boat. (J. B. Phillips photograph; courtesy Monterey History and Art Association.)

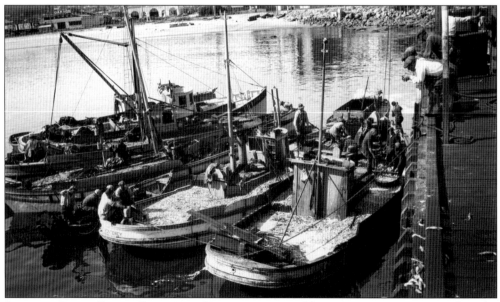

SICILIAN SQUID BOATS READY TO UNLOAD AT THE MONTEREY WHARF. Note that the fishermen are standing knee-deep in squid. (J. B. Phillips photograph; courtesy Monterey History and Art Association.)

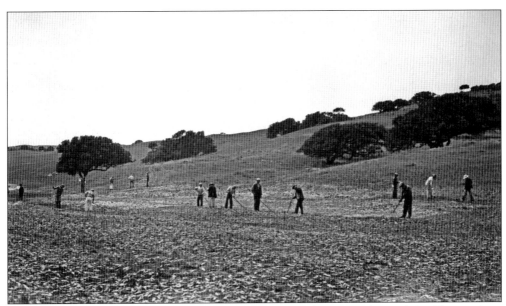

SQUID DRYING. At the turn of the last century, the City of Monterey banned the Chinese from drying squid within city limits. So they moved their squid-drying operations in the 1920s to big empty fields off the Monterey-Salinas highway, known as Tarpy Flats, located across from what is now the Monterey Airport. The Chinese bought the squid from the Sicilian fishermen and trucked it to the drying fields. The squid were dipped in brine and laid out on the ground for 10 to 12 days to dry. If a person needed a job in those days, he or she could work in squid-drying fields and be paid 25¢ an hour to rack up squid. (Jack Yee photograph; courtesy Monterey Public Library, California History Room.)

GABE. This is Harold "Gabe" Bicknell's work record at Won Yee's squid-drying fields in 1935. According to John Steinbeck, Gabe, who also worked collecting specimens for Ed Ricketts, was a model for Mac in Steinbeck's *Cannery Row*. Each employee of the squid-drying companies received a brass token. The number at the upper right corresponded to the numbered token so Gabe and other employees would be paid correctly. (Wing Chong Company Records; courtesy Monterey Public Library, California History Room.)

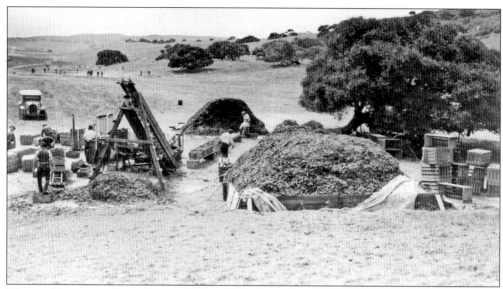

"SQUID MOUNTAIN," AROUND 1930. By 1910, there were at least three Chinese squid-drying operations at Tarpy Flats near the Monterey airport. Won Yee, who came to Monterey in 1918, and his partner C. L. Sam were the models for the character Lee Chong in Steinbeck's *Cannery Row*. Yee owned the largest and most successful of the squid-drying businesses and partnered with others. People referred to his squid-drying grounds as Squid Mountain or Heliotrope Hill because of the purple color in the squid. It was also known as Halitosis Hill due to the smell. On the left is the conveyor belt Yee ingeniously used to remove debris from the squid. (J. B. Phillips photograph; courtesy Monterey History and Art Association.)

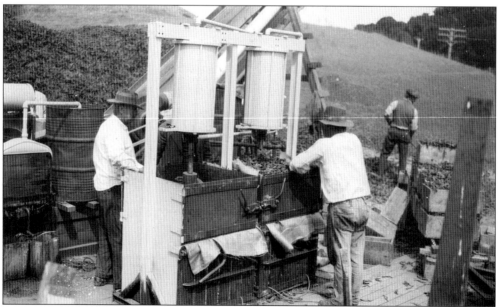

SQUID SQUASH. All of this squid was shipped to Asia. Since space on a ship was highly valued, the squid were squashed into bundles and then baled for shipment. (J. B. Phillips photograph; courtesy Monterey History and Art Association.)

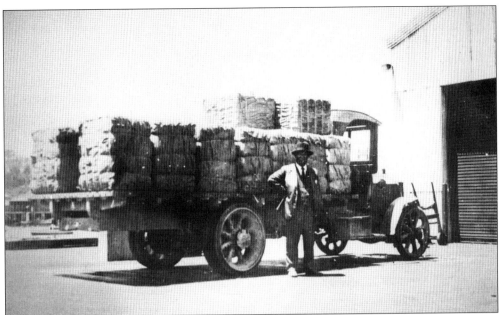

WON YEE. Yee stands proudly in front of his truck stacked with bundled dried squid in 1930. In that year, Yee shipped 10,000 tons to Hong Kong with an estimated value of $50,000 to $80,000. In the 1930s, the shipping companies did not charge by weight but by volume. Won Yee came up with this system of smashing all the squid into small manageable bundles. (Jack Yee photograph; courtesy Monterey Public Library, California History Room.)

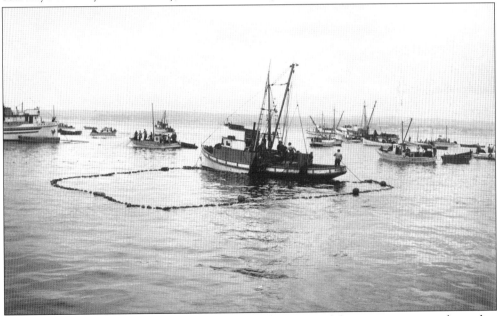

SQUID FISHING. After the sardine fishery collapsed, Monterey fishermen concentrated on other fisheries, including squid, anchovies, rockfish, and mackerel. Many Monterey fishermen went south to fish tuna. Although they never fished for it before, they just treated it like a big sardine. This photograph, taken in 1957, shows a purse seiner spreading a net for squid. (J. B. Phillips photograph; courtesy Monterey History and Art Association.)

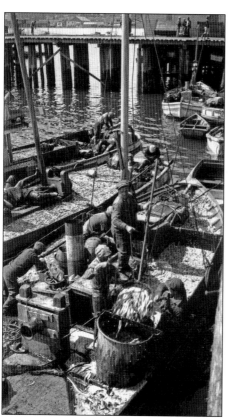

UNLOADING SQUID INTO A HOPPER, 1930S. Here Sicilian fishermen unload fresh squid at the Monterey Wharf using buckets. (J. B. Phillips photograph; courtesy Monterey History and Art Association.)

UNLOADING SQUID INTO A HOPPER, 1957. After the collapse of the sardine fishery, Monterey fishermen began to heavily fish squid. Once considered a junk fish, squid today is economically the number one fishery in California. (J. B. Phillips photograph; courtesy Monterey History and Art Association.)

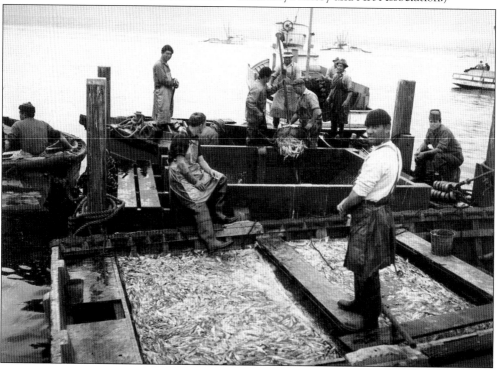

Ten

FISHING AND TOURISTS

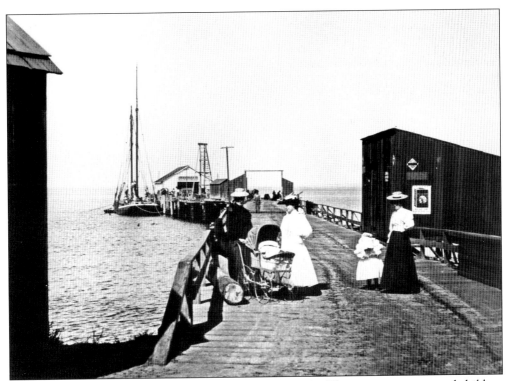

SUNDAY OUTING TO VISIT THE MONTEREY WHARF, 1901. These young women and children were some of the early visitors attracted to the Monterey Wharf. In the background is the Pacific Steamship Company building. (J. K. Oliver photograph; courtesy Monterey Public Library, California History Room.)

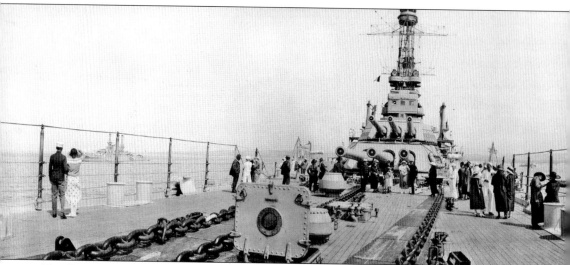

THE PACIFIC FLEET VISIT. Visitors throng the deck of the USS *New Mexico*, the flagship of the navy's Pacific Fleet, during its visit to Monterey on August 28 and 29, 1919. Note how dressed up everyone is. The visit of the Pacific Fleet to Monterey was a celebrated event with tourists and

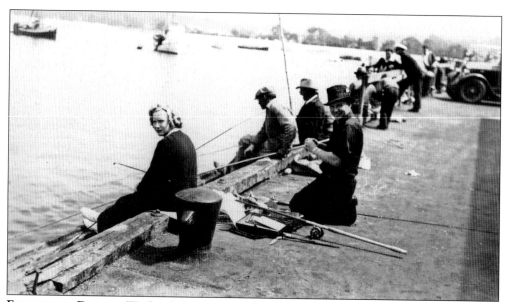

FISHING FOR DINNER. Weekenders fish on Municipal Wharf No. 2 (or "new wharf") on a lazy August day in 1938. (William L. Morgan photograph; courtesy Monterey Public Library, California History Room.)

locals watching the ships and sailors visiting Monterey. Perhaps a few even fished. (A. C. Heidrick photograph; courtesy Monterey Public Library, California History Room.)

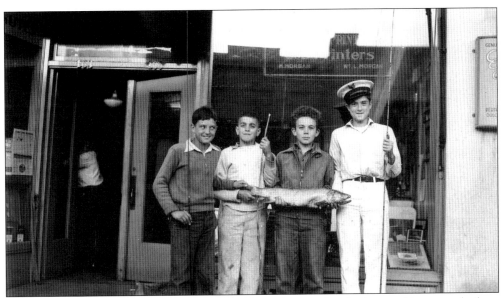

RARE CATCH. These happy young men are holding a barracuda, which one of them caught from the new wharf. There must have been an El Niño affecting the bay in 1939, since barracuda are warm-water fish. (William L. Morgan photograph; courtesy Monterey Public Library, California History Room.)

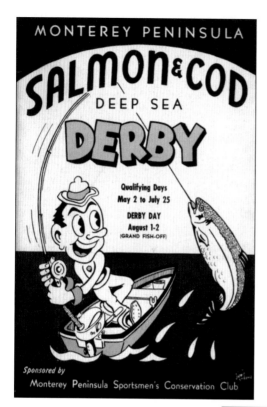

SALMON AND COD DERBY. Monterey Bay has always been a great place to fish, not just for commercial fishermen but also as a sportfishermen's paradise. This is the cover for the 1957 Salmon and Cod Deep Sea Derby, an annual event held in the 1950s. (Courtesy Monterey History and Art Association.)

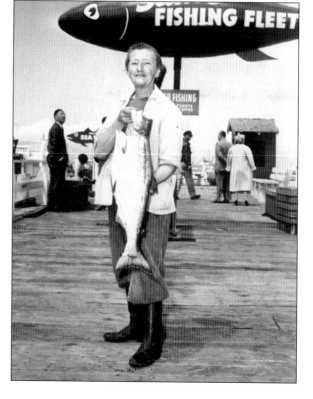

A WINNING SALMON. In this 1957 photograph, Bessie Ostrow holds her prize-winning salmon near Sam's fishing outfit. There were separate prizes for both the men and women. The men could win a new boat or fishing gear, and the women could win a new vacuum cleaner and other kitchen appliances. (Lee Harbick collection; courtesy Monterey Public Library, California History Room.)

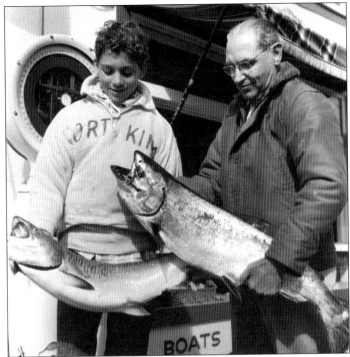

SALMON TROPHIES. These two fishermen, young L. H. Carlson (left) and John Connolly, are getting ready to have their salmon weighed during the Salmon Derby in May 1957. Carlson's prized salmon weighed in at 22 pounds. (George T. C. Smith photograph, Lee Harbick collection; courtesy Monterey Public Library, California History Room.)

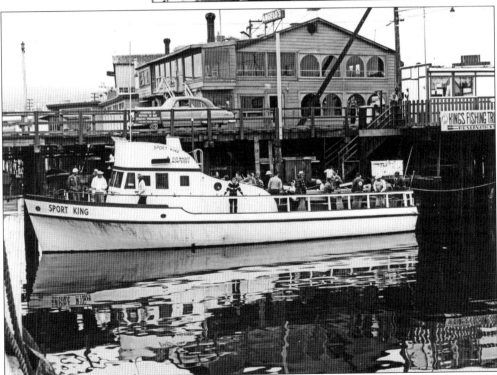

SPORT KING. The *Sport King* leaves Fisherman's Wharf to take a group of sportfishermen out for a day of angling on the bay in the 1950s. (Lee Harbick collection; courtesy Monterey Public Library, California History Room.)

THE LONE FISHERMAN. This angler is fishing near Municipal Wharf No. 2 in the early evening of February 22, 1948. (William L. Morgan photograph; courtesy Monterey Public Library, California History Room.)

ARTIST AT THE WHARF, 1946. Monterey and Monterey Bay have attracted artists since the 19th century. A favorite subject has been Fisherman's Wharf and fishing boats. (William L. Morgan photograph; courtesy Monterey Public Library, California History Room.)

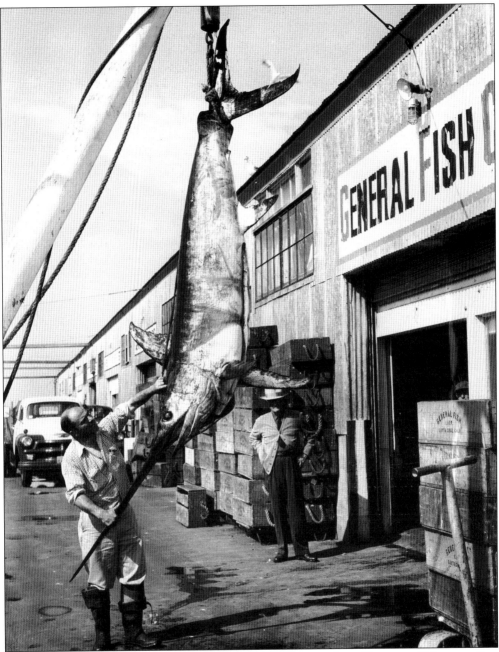

CATCH OF THE SEASON. This sailfish, a very rare specimen in the cold waters of Monterey Bay, was probably a visitor during climatic changes from El Niño. Cottardo "Monk" Loero, manager of General Fish Company, displays this fine fish to residents and tourists in October 1956. (William L. Morgan photograph; courtesy Monterey Public Library, California History Room.)

FISH MARKET. Joe Riccobono exhibits fish available at Liberty Market on Fisherman's Wharf in 1965. Joe is holding a spiny lobster, which in California can get very large. In 1938, abalone diver Roy Hattori caught one that, when unrolled, was over five feet long. Believing that he had a record catch, he sent the giant crustacean to his mother in Monterey for safekeeping. Later when he asked her how his lobster was, she replied, "Tough." (MacDougall King photograph, Lee Harbick collection; courtesy Monterey Public Library, California History Room.)

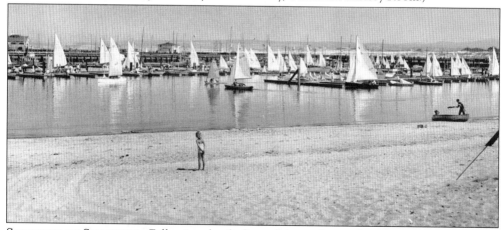

SAILBOATS IN SEPTEMBER. Following the decline of the sardine industry, recreational boating and sportfishing became popular pastimes on Monterey Bay. Commercial fishing continued as well. Here sailboats are moored in the small boat harbor next to Wharf No. 2 in 1960. (William L. Morgan photograph; courtesy Monterey Public Library, California History Room.)

STROLLING THE WHARF. Still a working wharf in 1940, by the 1950s, Fisherman's Wharf had become a favorite tourist destination for its fish markets and restaurants as well as its views of Monterey and the bay. (Rey Ruppel photograph; courtesy Monterey Public Library, California History Room.)

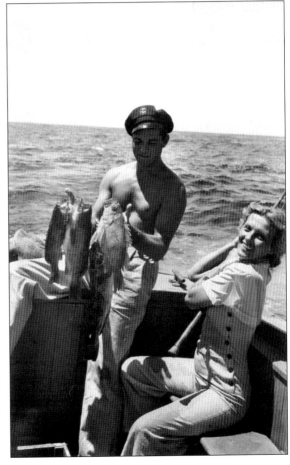

ON THE BAY. Scott and Hillary Taylor show off the rockfish he caught on Monterey Bay in 1940. (Tim Thomas, donor; courtesy Monterey History and Art Association.)

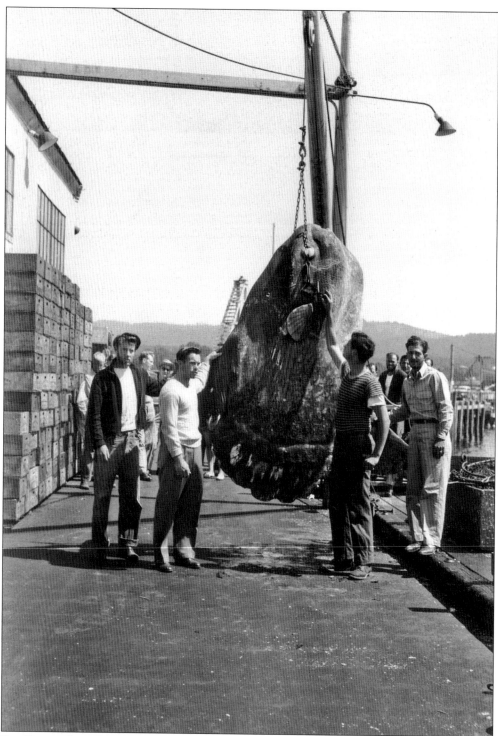

BIG CATCH. Sportfishermen on the Monterey Bay caught this mola mola, or sunfish, on June 20, 1946. These funny-looking creatures can get as big as a Volkswagen bug! (William L. Morgan photograph; courtesy Monterey Public Library, California History Room.)

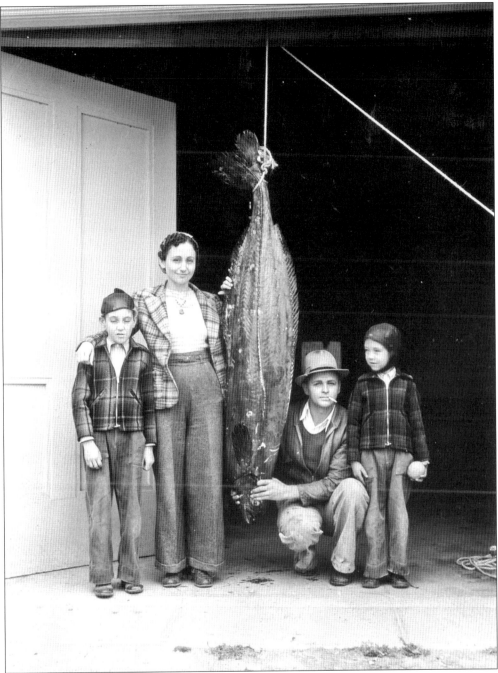

RAGFISH. This is L. A. Yeney and family standing in the doorway of their garage with a very large ragfish. Yeney caught this rare deepwater fish off the Monterey breakwater in 1940. Fish and Game biologist Julius B. Phillips photographed the unusual fish for an article on Yeney's catch that he wrote for a Fish and Game journal published later that year. Fish and Game scientists often wrote about and recorded unusual specimens landed in Monterey Bay. Because of these special reports and records, El Niño weather conditions can be tracked before the beginning of the 20th century. (J. B. Phillips photograph; courtesy Monterey History and Art Association.)

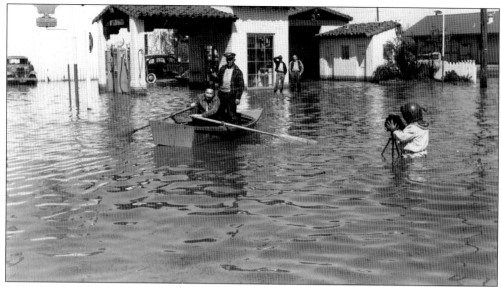

1941 FLOOD. During extreme weather situations, such as an El Niño, Monterey's waterfront has occasionally flooded. The diver is Eddie Bushnell, who had a salvage business and contracted with all the cannery owners to take care of their sardine hoppers. Every few years, he would haul them out of the water for cleaning—then haul them back. He was also responsible for their initial installation, including laying the entire pipe. (William L. Morgan photograph; courtesy Monterey Public Library, California History Room.)

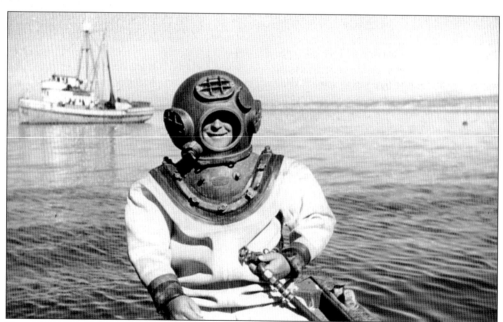

DIVER EDDIE BUSHNELL. Here is Eddie Bushnell getting ready for a dive. In the 1940s, he invented underwater camera housing and took some of the first underwater photographs of Monterey Bay. (William L. Morgan photograph; courtesy Monterey Public Library, California History Room.)

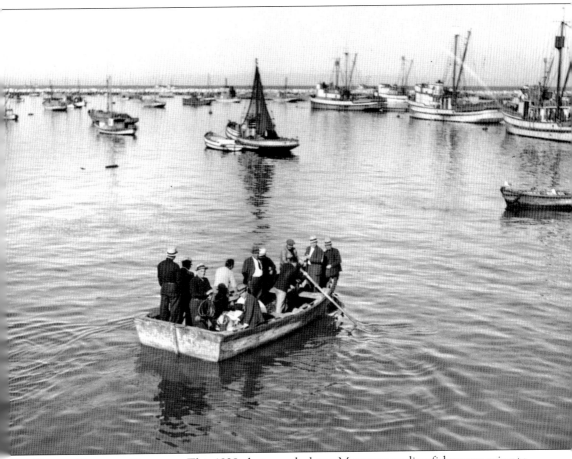

THANK YOU AND GOODBYE. This 1938 photograph shows Monterey sardine fishermen going to work. Note that they are all in suits. They dressed up for work just like everyone else, and the boat was their office. Just like businessmen, they wanted to look good when they went to work. They changed into their fishing gear once they got on the boat. (J. B. Phillips photograph; courtesy Monterey History and Art Association.)

INDEX